FIFTY
DRESSES
THAT
CHANGED
THE
WORLD

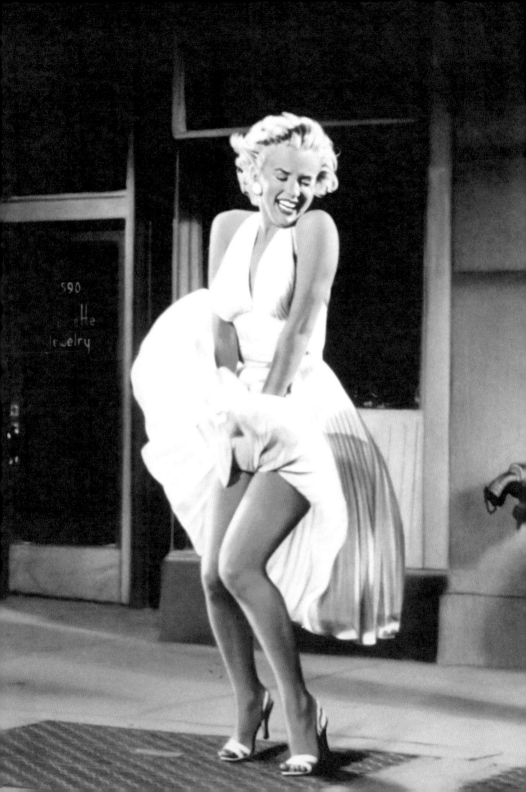

DESIGN MUSEUM

FIFTY DRESSES THAT CHANGED THE WORLD

conran
OCTOPUS

FIFTY
DRESSES

FIFTY
DRESSES

Meryl Streep's character in *The Devil Wears Prada* (2006) makes a powerful pitch for understanding the significance of fashion, especially to those who see in it nothing but the frivolous and the self-indulgent. 'The colour of the sweater,' she says, 'made in the Far East, on an industrial scale, providing work for poor families, and putting a developing economy on the road to the First World, is the afterglow of a couture collection.'

Fashion can be understood in many ways. It is both an industrial and a cultural phenomenon, one that goes to the heart of what we understand as design. The Industrial Revolution in Britain was fuelled by technical innovation in manufacturing textiles. Contemporary fashion is a huge and extremely vigorous industry, of which the catwalk collections provide only a glimpse. That is why fashion continues to be an important part of the Design Museum's programme.

The collection of iconic dresses included in this book provides an introduction to the path fashion has taken in the past century. It is a story that embraces social and economic change and radically fluctuating positions on gender and sexuality. These are dresses that have encapsulated particular moments in time in a particularly powerful way, and that have provided fascinating insights into the people who wore them as well as the people who designed and made them.

Deyan Sudjic, Director, Design Museum

Right: Technology and wearable style combine in the hauntingly illuminated LED dress from Hussein Chalayan's 2007 Airborne collection.

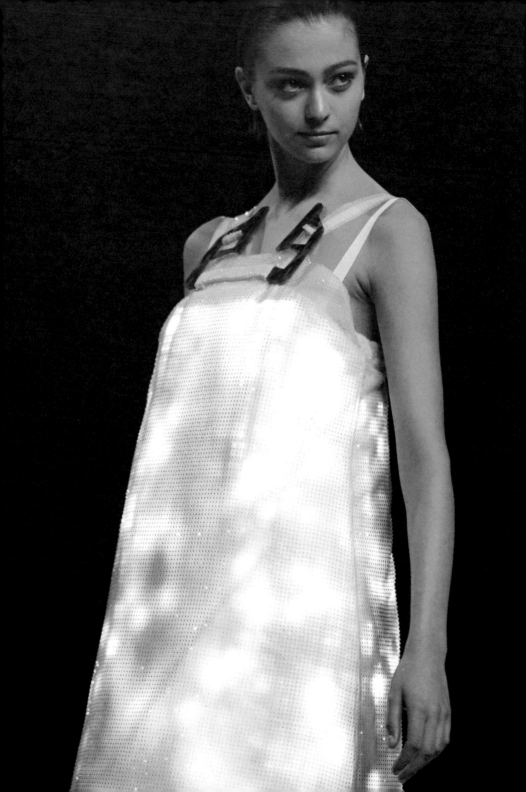

DELPHOS PLEATED DRESS

1915
Mariano Fortuny

As the twentieth century began, the accumulation of scientific knowledge, technical developments and cultural questioning that had preoccupied the previous decades brought about accelerated societal change. There was never a more fitting time for fashion to adopt a responsive visual language that would keep up with, and sometimes guide, the rapid pace of modern life. In this headlong rush towards modernity, however, the appropriation of novel technologies and materials often went hand in hand with a reinterpretation of traditional styles and techniques.

In 1909 the Spanish-born couturier Mariano Fortuny (1871–1949) patented a method of pleating silk that enabled him to produce flowing, romantic gowns that were quickly taken up by the European artistic elite. A far cry from the constricting costumes of the nineteenth century, these loose, lightweight dresses allowed a radical freedom of movement, even as they daringly emphasized the contours of the female form. Despite their liberating modernity, however, Fortuny's designs were rooted in tradition and often referenced antique and other historical styles.

Perhaps Fortuny's greatest achievement, the Delphos dress is a reinterpretation of the draped and flowing clothing of ancient Greece. Through the structural quality of the pleating, it captures all the sensuality and romance of the era, as imagined by late nineteeth-century academic painters such as Sir Frederick Leighton. This pleating technique was a closely guarded secret and has never been successfully copied since.

Right: Three variations of Fortuny's groundbreaking pleated dress. Below: The Delphos dress accentuated the natural shape of the figure and allowed a revolutionary freedom of movement.

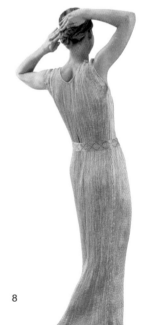

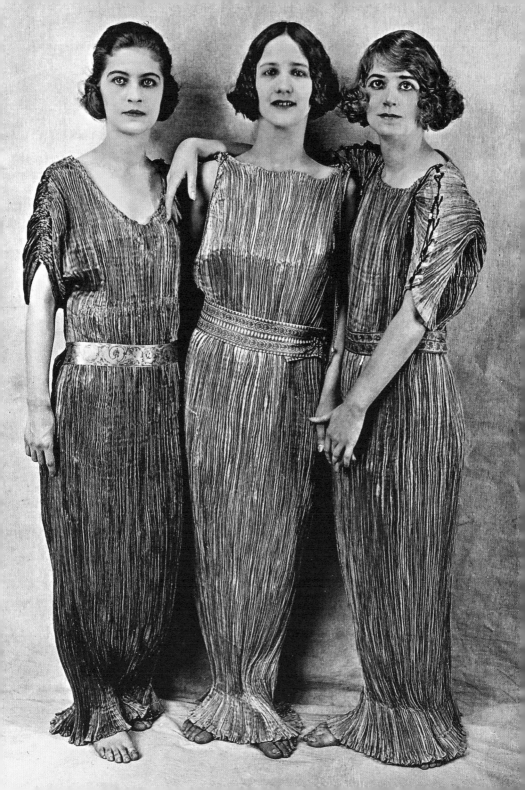

JERSEY FLAPPER DRESS

c.1926
Coco Chanel

Boyishly bobbed hair and the short-cut shift dress became the uniform of emancipated 'modern' young women in the mid-1920s. With their slang, exposed limbs and go-getting attitude, these 'flappers' showed defiance, daring and strength in a male-dominated world. The flapper dress was a physical liberation, overthrowing the tyranny of the corset and, more prosaically, cutting down the time it took to get dressed. But the garment also reflected social change, as a new generation of middle-class women challenged the gender and class repressions of the past.

The look associated with flappers was pioneered in the neutral-toned and simply cut designs of Coco Chanel (1883–1971). Made from utilitarian jersey fabrics, her clothes were about comfort and ease of movement with a loose silhouette that abandoned a tucked-in waist and mounds of heavy fabric. The simplicity of these dresses also meant they could be easily run up at home, making the look accessible to the masses – it was one of the first trends not to be restricted to the wealthy or a fashion elite.

However, this was a short-lived style, thwarted at the end of the decade by the economic collapse of 1929. Times now became too serious for lighthearted defiance, and it would be nearly 40 years before hemlines would rise again.

Right: The constrictions of corsets and padding were swept away as the loose-fitting utilitarian flapper dress gave everyday liberation to 'modern' working women.

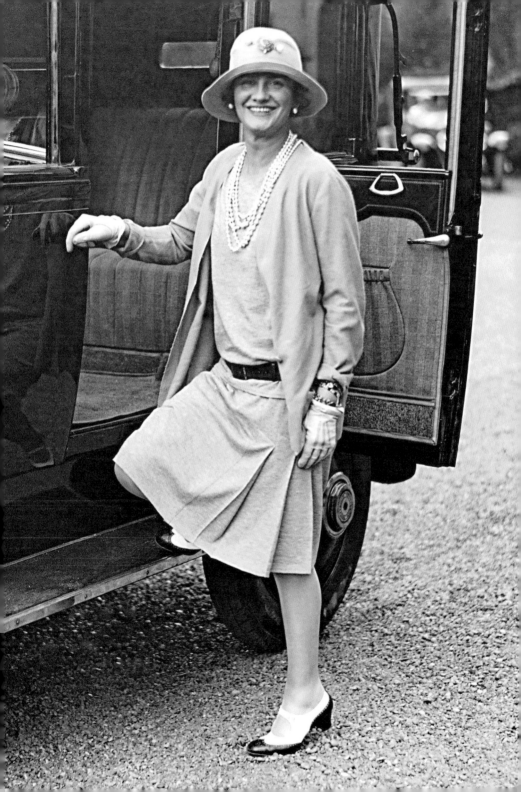

GODDESS DRESS

The catastrophe of World War I brought about a radical reappraisal of gender, class and creativity. There was a freedom in the air that enabled a few to break away from convention and explore new horizons. Just as the dancer Isadora Duncan combined a passion for the Classical world with a natural and sensual approach to the human body, the French designer Madeleine Vionnet (1876–1975) looked back to ancient Greece as she sought to liberate women from the constraints of corsets and padding.

Vionnet's bias-cut dresses allowed fabric to float freely around the body, enhancing natural curves and accentuating – though not moulding – the female form. Women were free to express a softer femininity. The style depended on an expert understanding of pattern cutting and the properties of fabric. Vionnet is often credited with establishing the bias cut as one of the staples of modern fashion – certainly, she understood perfectly that to cut cloth on the diagonal made it more flexible and elastic – and therefore much easier to drape.

Simple and spontaneous as the Vionnet style appears, it entailed meticulous attention to detail. Designs were carefully worked out on miniature dolls before being made up as full-sized finished garments.

Right: With bohemian licence in the air Madeleine Vionnet's bias-cut designs created freedom of movement for the new breed of 1930s women.

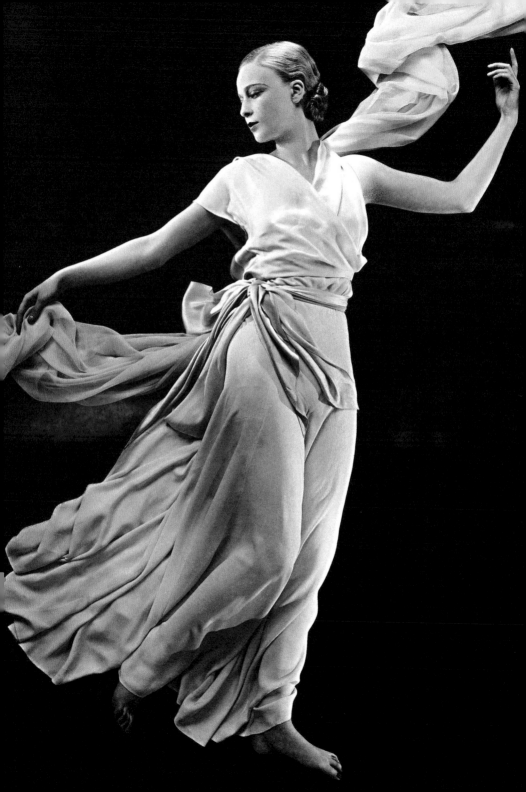

WALLIS SIMPSON'S WEDDING DRESS

1937
Mainbocher

American socialite Wallis Simpson was married in 1937 dressed in a simple floor-length gown with matching long-sleeved jacket – all in 'Wallis Blue', a colour specially developed to match her eyes. Created by the United States-born but Paris-based designer Mainbocher (Main Rousseau Bocher 1891–1976), this understated gown would become one of the most copied dresses of all time.

The wedding was the culmination of the scandal of the century. The Duke of Windsor's uncompromising love for the divorcee had forced him to abdicate from the British throne the previous year, provoking a constitutional crisis that had shaken the British establishment to the core. However, to a US audience less concerned with royal protocol and tradition, it appeared only that a strong American woman had succeeded in obtaining true love in the face of adversity and criticism.

Accordingly, this modest bridal gown was subjected to unprecedented public scrutiny. Within days of the ceremony, copies of the dress were available for sale in New York, and within weeks a cut-price version of the 'Wally' became available in department stores throughout the country. The austere simplicity synonymous with Simpson's style, combined with the scandalous notoriety of its wearer, made the dress a sensation that hinted at the direction fashion would take in the decade to come.

Right and below: Wallis Simpson and the Duke of Windsor as newlyweds. Mainbocher's gown achieved that most difficult of sartorial feats – the marriage of restraint and glamour.

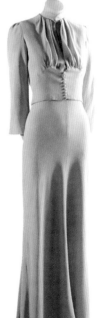

14

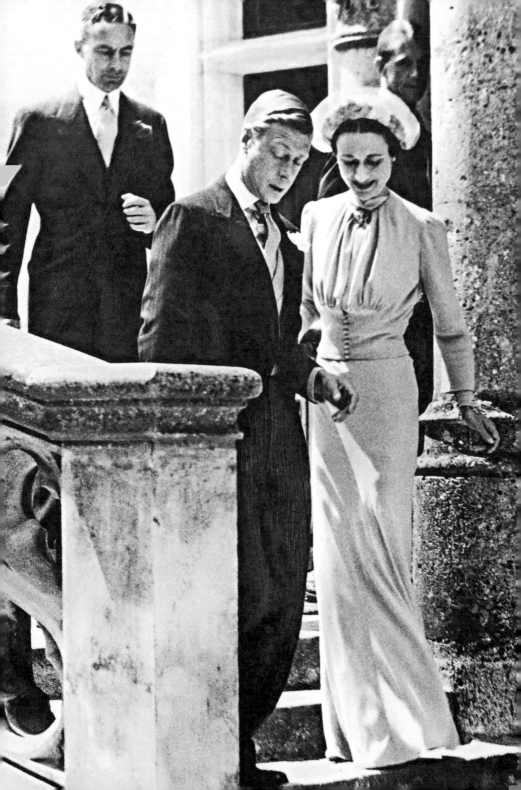

THE NEW LOOK

From the ruins of post-World War II Europe, the New Look came like a blast of optimism that resuscitated the Paris couture industry and outlined an aesthetic for the decade of economic and social renewal that followed.

This fashion phenomenon, launched by French designer Christian Dior (1905–57) in 1947, endured well into the 1950s, defining a new era of defiance, resilience and hope. Dior's belief was that the public was now more than ready to embrace a new, luxurious and life-affirming style that would obliterate the mend-and-make-do mentality of the war. Soft shoulders, a waspy waist and the indulgent volume of a full-flowing skirt were exactly what Dior's *femme-fleur* (flower-woman) wanted.

Dior had originally branded his 1947 fashion launch under the Corolla and Eight lines, but he apparently adopted the more catchy New Look sobriquet after the editor-in-chief of *Harper's Bazaar* exclaimed, 'It's such a new look!' Dior's couture house was inundated with orders from international celebrity clients such as Margot Fonteyn and Rita Hayward. A style was born, Paris was back on the fashion map, and Dior set a precedent by selling exclusive rights to individual designs, enabling the New Look to be manufactured internationally as a worldwide brand.

Right: Photographed amid rococo opulence, this Dior model adorns as much as she is adorned. Below: Wartime austerity was left far behind with Dior's extravagant and feminine New Look.

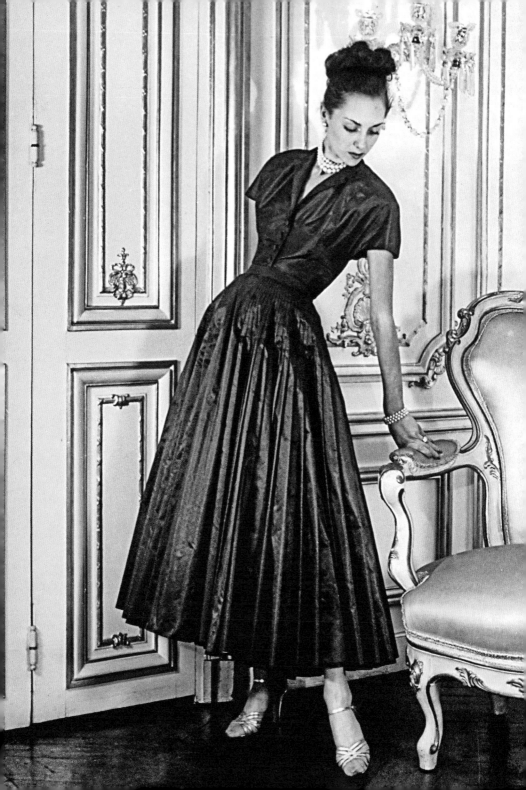

SHOCKING-PINK DRESS

1947
Elsa Schiaparelli

Elsa Schiaparelli (1890–1973) was one the most highly renowned fashion innovators in the period leading up to World War II. A rival to Coco Chanel, she made her name through designing clothes that were flamboyant expressions of extravagant ideas. It was not just a matter of style for style's sake, however. For Schiaparelli, enabling women to make their mark and express their identity through fashion was one route to equality.

Schiaparelli moved in cutting-edge art circles in New York and Paris, and became closely associated with the Surrealists. This led to various collaborations, notably with Salvador Dalí, with whom she notoriously designed a white organdie evening gown decorated with an oversized lobster (1937). For all her artistic bent, however, her technical innovations were numerous. She pioneered the use of zips, shoulderpads and synthetic fabrics, while her sportswear designs gave women the physical freedom to compete professionally. She is also celebrated for her use of brilliant, even garish colours – most notably 'shocking pink', which took its name from the first of her proprietary perfumes, Shocking (1937).

Schiaparelli's experimental, 'anything goes' approach brought to fashion a conceptual playfulness that was, perhaps, more about ideas than the craft of the couturier. However, though many of her contemporaries described her scathingly as an artist who made dresses, her legacy has been to break down barriers between art and design, paving the way for the twenty-first century's more eclectic approach to fashion.

Right: Conceptual playfulness and an experimental spirit made Elsa Schiaparelli's theatrical designs new and exciting. The hyperfeminized shape and colour, together with the floral embroidery, seem to turn the wearer into a blossoming flower – another example of the *femme-fleur* imagery that was revived in the postwar era.

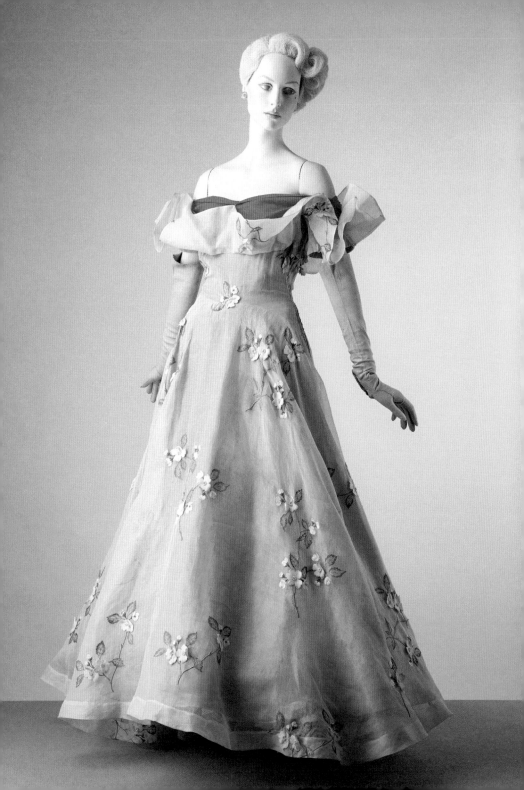

ELIZABETH II'S CORONATION DRESS

'Glorious' is the word the British Queen Elizabeth II reputedly used to describe her coronation gown when she tried on the finished article just before the great day in 1953. Designed by the royal dressmaker Norman Hartnell (1901–79), the dress dazzled the world as millions around the globe gathered around television sets and in cinemas to watch the new Queen walk along the aisle of Westminster Abbey. Like Wallis Simpson's wedding dress of a decade and a half before, it was an early example of the mass exposure to which fashion was becoming subjected in the burgeoning media age.

Hartnell's brief was to create something that would be comfortable and wearable, yet appropriate to the religious and regal symbolism of the occasion. But more media-savvy advisers insisted, too, that the gown had to stand out in the visually busy environment of a royal ceremony – to be, in short, photogenic and camera-friendly. It was Hartnell's eighth design that finally fulfilled all the necessary criteria.

A ceremonial dress of white satin, embroidered with gold and silver thread and pastel-coloured silks, and encrusted with seed pearls and crystals, the coronation gown produced a shimmering spectacle for the privileged few actually in attendance. But for the rest of humanity, too, its crisp white outline set against the tonal greys of the all-encompassing Abbey effectively conveyed the majesty and glamour of British royalty at its zenith.

Right: Coronation portrait of Queen Elizabeth II by the English fashion photographer Cecil Beaton. Norman Hartnell's sumptuous gown looks as if it has come straight from a Van Dyck painting and gives some indication of the rich ceremonialism that chracterized this mass-media event.

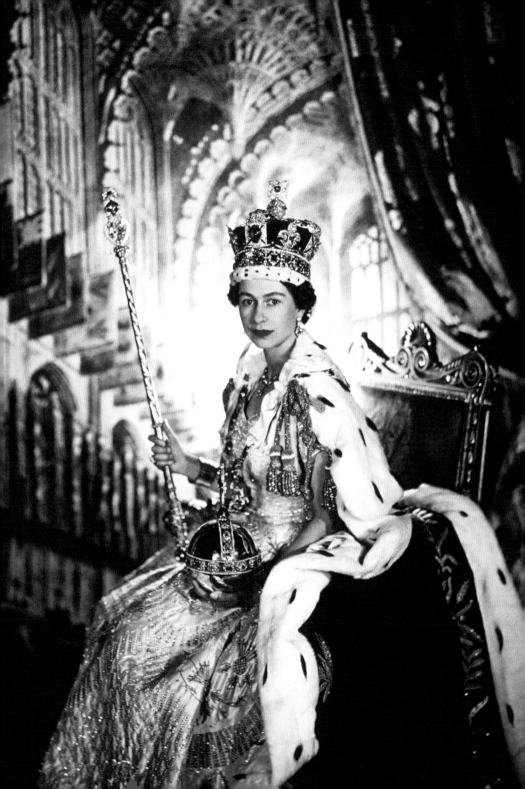

MARILYN MONROE'S
THE SEVEN YEAR ITCH DRESS

1955
Travilla

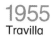

The glorious cinematic moment when Marilyn Monroe's figure-hugging white halterneck dress flies up as she stands over a subway vent established William Travilla (known professionally simply as 'Travilla' 1920–90) as a catalyst in the creation of an icon. His name is for ever destined to be overshadowed by the star he dressed, but the power of the breathtaking vision he helped conjure will never fade.

 The Los Angeles-born Travilla was one of several contract designers working for Twentieth Century-Fox at the time, and designer and actress are said to have first met when she asked to borrow his fitting room to try on an outfit. *The Seven Year Itch* (1955) was one of eight movies that the pair would eventually work on together. Slipping past the repressive morality of the times, this brief scene was a cheeky gesture of defiance that could have been pulled off only by one of the world's biggest – and brightest – stars.

Right and below: A moment of pleasure – Marilyn Monroe's halterneck dress blows up provocatively in this scene from *The Seven Year Itch*. The costume designed by William Travilla created an iconic – and curiously innocent – moment in the development of a twentieth-century icon.

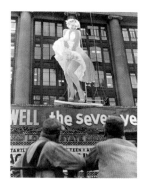

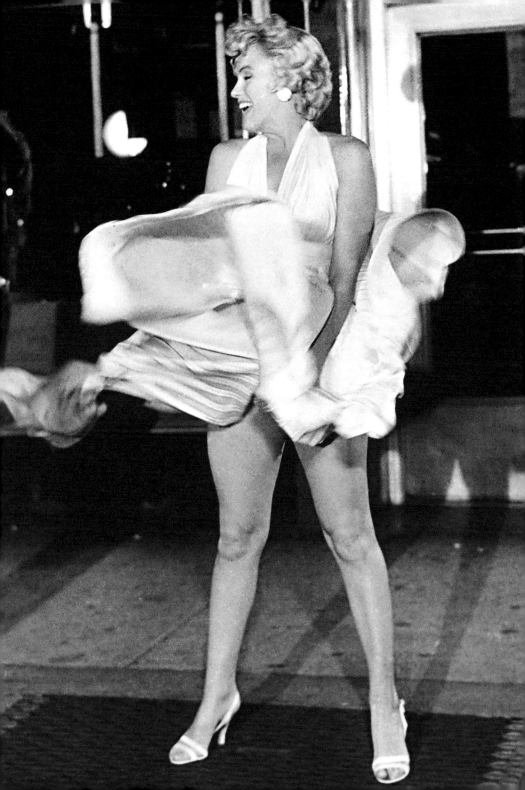

CHANEL SUIT

Although not strictly speaking a dress, the Chanel suit demands inclusion in this book because of the revolutionary impact it had, not just on how women dressed but also on how they were perceived in the world of work.

Coco Chanel (1883–1971) first came to prominence during World War I, when her simple, elegant designs, constructed around ingenious tailoring, enabled women to slough off the heavy extravagances of the Belle Epoque and finally dress for themselves – for their own comfort and pleasure. It was the genius of Chanel that had helped forge the look of the 'flappers' – the liberated, bohemian women of the 1920s (see pages 10–11).

The classic Chanel suit – a knee-length skirt and square-shouldered jacket that was feminized with gold buttons and contrasting trim – first emerged in the more serious, straitened times of the 1930s. To make her jackets Chanel controversially used tweed – a cheap fabric then considered masculine and working class – though, as if to make up for that, she lined her creations with silk or even fur. Once again the secret of the design lay in innovative tailoring. Trim, elegant, comfortable, this was *the* look for women who meant business …

During the following decades the Chanel suit proved its remarkable staying power, even as it evolved. From the lunching ladies of the 1960s to the power-dressing businesswomen of the 1980s and the hyper-fashion-conscious celebrities of today, it has remained a symbol of classic design, status and style. For Karl Lagerfeld – the designer responsible for the suit's development since 1983 – Chanel 'established a look that for our century is what the two- or three-button suit is for men'.

Right: This 1950s variation of the square-shouldered jacket is feminized with a playful, bold white trim. Below: The Chanel suit has provided no-nonsense yet chic businesswear for women for decades.

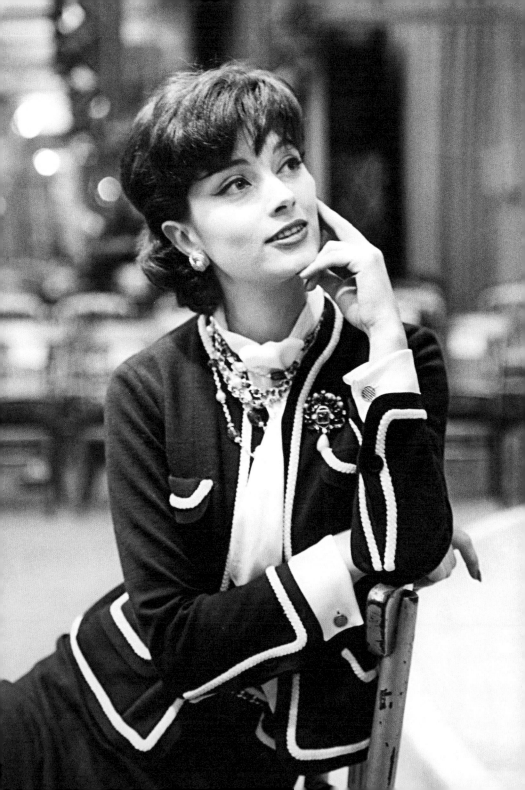

LITTLE BLACK DRESS

The 'little black dress', or LBD, has become a genre in its own right – a garment of chic and versatile simplicity that no respectable wardrobe should be without. Instigated by Coco Chanel (1883–1971), and reinterpreted by virtually every designer since, perhaps its most notable manifestation is the version worn by Audrey Hepburn in *Breakfast at Tiffany's* (1961) and designed by the aristocratic French designer Hubert de Givenchy (1927–).

The premise behind the LBD is that it can be worn for a variety of occasions from one season to the next, with classic and timeless confidence. A dress that says it all without the need to shout, its purpose is to be a uniform that lends to its wearer an air of demure sophistication. In *Breakfast at Tiffany's* it was the perfect costume for Hepburn's character, the mercurial Holly Golightly, to don as she attempts to fool and take on the world.

Givenchy designed the dress knowing the wearer well. He later described his first impression of Hepburn's look as being that of an extremely delicate creature. With her gamine beauty and fragile frame, Hepburn might represent vulnerability, but with this simple dress Givenchy also endowed her with a blend of restrained power and urbane sensuality.

Right and below: Although not the first of its type, Givenchy's 'little black dress' worn by Audrey Hepburn in the hugely successful *Breakfast at Tiffany's* has come to symbolize this most versatile of chic party outfits.

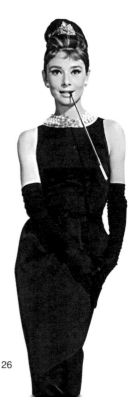

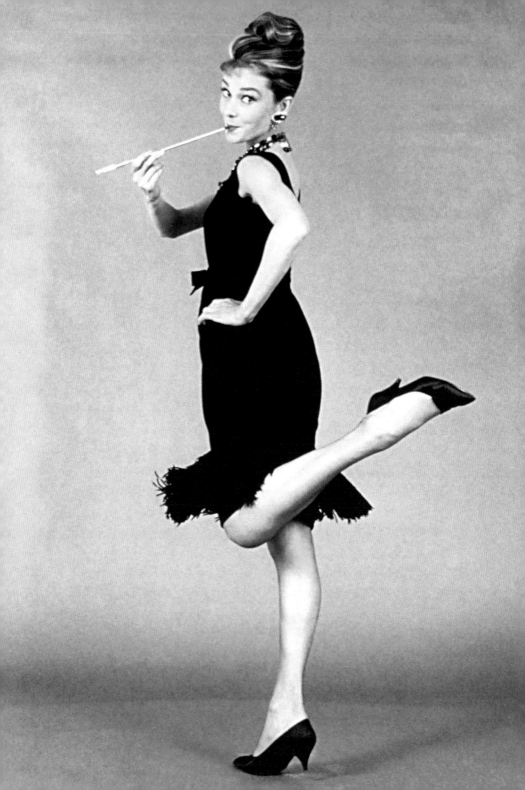

JACKIE KENNEDY LOOK

The McCarthyist era of the 1950s, which had aggressively proclaimed what the United States was not, was superseded in the early 1960s by a period of self-marketing designed to reinvent the nation as a progressive and beneficent world leader. From Pop art to the President's wife, everything served to reinforce it's confident, vigorous air of self-belief.

Stunning yet unostentatious, challenging yet uncontroversial, Jackie Kennedy sent a powerful visual message to the world that was best captured in the dresses she commissioned from the Hollywood designer Oleg Cassini (1913–2006). Her choice of designer was, in part, a reaction to the criticism the First Lady initially received for wearing clothes by French couturiers. Cassini offered the perfect solution – a homegrown designer who could stylishly interpret the European look.

Sophisticated, intelligent and cosmopolitan, Jackie Kennedy's style announced the coming of age of the United States. Cassini's creations were a key ingredient. Simple lines and bold colours created an impression of both understated femininity and restrained modernity. The time was not yet right for the President's wife to assume the more vocal, active role that would be claimed by Hillary Clinton several decades later. Instead, she used the space allotted to instil a memory that is still vivid today.

Right: Jackie Kennedy in a startlingly simple pale gown that makes the President's wife the focus amidst a sea of black-suited men.
Below: The sophistication and modesty of the outfits worn by Jackie Kennedy in the early 1960s represents the United States's growing confidence on the world stage.

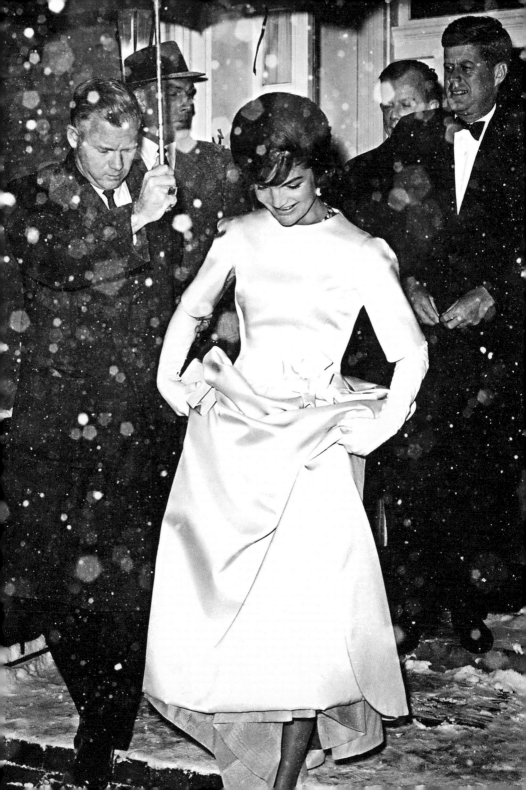

MOON GIRL COLLECTION DRESS

1964
André Courrèges

The future was to be white, bright and fun. Women in opaque visor-style goggles would wear dresses simple in profile and short of skirt – youthful, nubile beings standing to attention and ready for action, programmed by the garments that had transformed them into machines.

In Paris, André Courrèges (1923–) looked to the stars to invent a space-age style that swept across the English Channel to cause a Big Bang in London and beyond. The future was the miniskirt, which Courrèges invented in the early 1960s. The French designer's clothes were bold celebrations of technological and social change, frequently embracing modern synthetic fabrics such as plastic and polyurethane.

For all Courrèges's confident sci-fi style, however, his work had its darker side, an expression of uncertainty about the shape of things to come. Created against the backdrop of the Cold War and a society increasingly obsessed by consumerism and technology, Courrèges's geometric designs risked depersonalizing and defeminizing the female body – and thus foreshadowed the technocratic dystopia portrayed in the French filmmaker Jean-Luc Godard's *Alphaville* in 1965.

Right: A model wears a plastic Courrèges minidress with a self-assuredness that boldly proclaims the arrival of a brave new world.
Below: Three variations of the Moon Girl Pop frock.

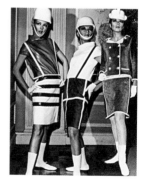

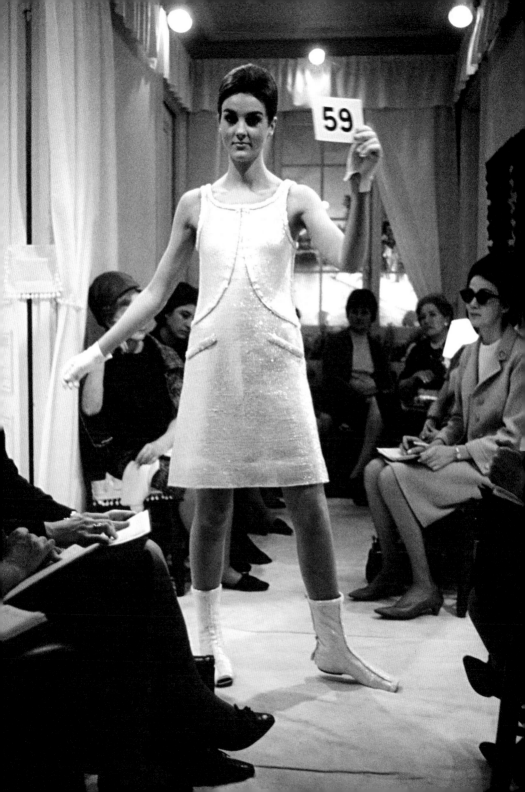

MONDRIAN
DRESS

This dress by Yves Saint Laurent (1936–2008) is another interpretation of the modern world, but this time using the aesthetic of fine-art theory rather than the look of sci-fi technology associated with André Courrèges (1923–). Appearing on the cover of French *Vogue* in 1965, the Mondrian dress announced an abstraction in fashion design that sought to equate the work of a couturier with that of an iconic Modernist artist – the Dutch painter Piet Mondrian (1872–1944) – whose grid paintings had become almost an international symbol for all things modern and stylish.

Saint Laurent's arresting statement in stripes of black and blocks of bright colour is a considered masterpiece that aimed to capture the pared-down essence of the human figure. The geometric design was constructed out of individual panels of coloured fabric with seams that were deliberately placed to hide the curves and character of the body. The result was a stark statement of order and simplicity that brought the designer into the realms of the sculptor and conceptual artist. Now fashion could be art, too.

Right: A recent variation of Yves Saint Lourent's Mondrian dress uses the aesthetic of the Dutch De Stijl movement to make a bold statement of modernity. Below: An image from the 1960s shows how the dress's design cleverly simplifies the shape of the body.

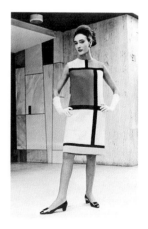

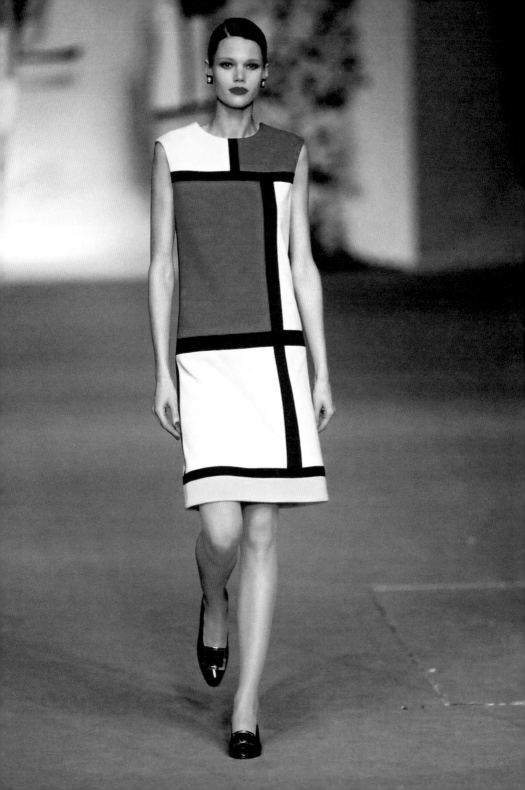

MINIDRESS

1965
Mary Quant

Still living under the shadow of postwar austerity in a city scarred by bombsites and soot-encrusted buildings, the youth of 1960s London was more than ready to explode into a brand-new look. Youthful irreverence hit the capital's grey and gloomy streets through bold colours and modern shapes, best demonstrated in the brilliant clothes of Mary Quant (1934–).

Influenced by the work of André Courrèges (1923–), Mary Quant took the emerging short skirt and made it even shorter. This provided an exciting and revealing style that was enthusiastically embraced by groovy girls searching for something new and youth defining. By 1965 the minidress was being sold through Quant's King's Road boutique, Bazaar. The dress's clean-cut, nursery-influenced style, ideally topped with an androgynous Vidal Sassoon five-point haircut, suggested a playful innocence as well as heralding the dawning of a new age.

Although initially an expensive boutique purchase, the simplicity of the minidress made it ideal not only for mass production but also for running up at home. The style spread far and wide, giving teenage girls and young women a new identity and helping define London as the happening place. If any look was a declaration of independence, fun and freedom against the uncertainties of the postnuclear world, it was this one. The mini was unstoppable. By the end of the decade, even the Queen's hemlines were shorter.

Right: Mary Quant hard at work in her studio creating the look of 1960s Swinging London. Below: Quant made short skirts even shorter, combining bold patterns and bold colours to create a look that provoked a sensation.

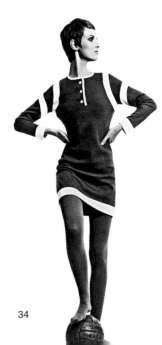

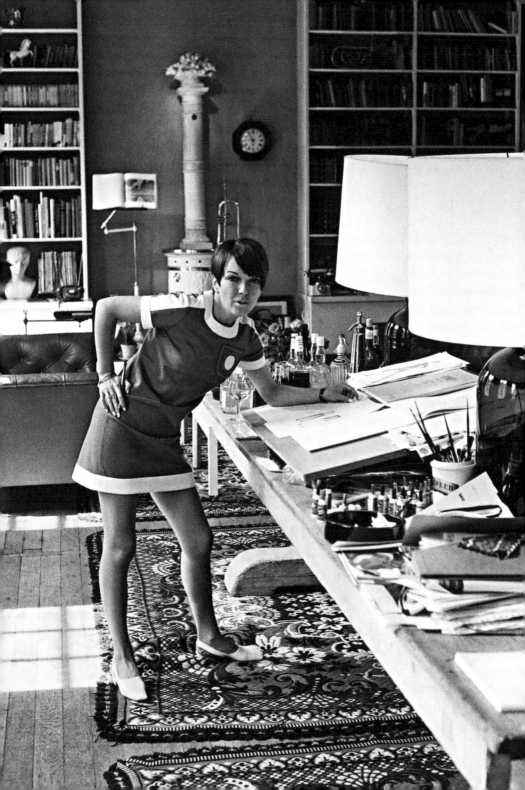

DIANA RIGG'S *THE AVENGERS* DRESS

1965
John Bates – aka
Jean Varon

Intelligent, beautiful and fiercely independent, *The Avengers* character Mrs Emma Peel offered a new role model for the emancipated woman of the 1960s. The stylish hit espionage series (1961–9) had already pioneered one strong, self-reliant television heroine in the form of Peel's predecessor, Dr Cathy Gale (played by Honor Blackman). Now that Diana Rigg was to enter the fray, the stakes were upped and the character togged out with something altogether more risqué.

Rigg's daring, hypersexualized costumes were provided by John Bates (1938–), a British designer who worked under the name of Jean Varon. While Bates was undoubtedly one of the biggest and most influential names in British fashion in the 1970s, he has been largely forgotten to history – a fate not suffered by his no more talented contemporaries such as Bill Gibb (1943–88) and Zandra Rhodes (1940–).

Bates's stroke of marketing genius was to launch a ready-to-wear range based on the *Avengers* outfits. These went on sale while the series was being screened – a perfect combination of aspirational product placement and popular-culture frenzy.

Right: The English model Jean Shrimpton wearing one of the more demure *Avengers* outfits; behind her is the designer, John Bates. Below: A sketch of one of the outfits worn by actress Diana Rigg.

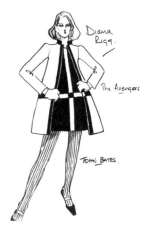

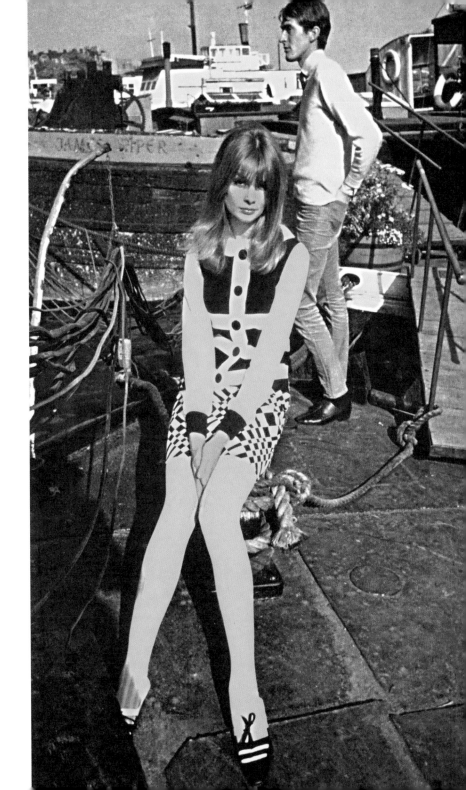

LAURA ASHLEY COTTON MAXI DRESS

1966
Laura Ashley

With the introduction of the maxi dress in 1966, the Welsh designer Laura Ashley (1925–85) popularized an antimodern, nostalgia-laced aesthetic that would endure into the 1970s and beyond. Change was once more in the air, and what was brewing now was a reaction against the brash modernity and disposable trends that had hitherto dominated the decade.

Just as the middle classes of the time were reclaiming the rundown period houses of Britain's inner cities, Laura Ashley plundered the nation's Victorian past to design dresses suggestive of simpler, more innocent times. Ashley also went on to become one of the first designers to offer a whole off-the-peg way of life, creating a range of home furnishings that completed the picture of homespun comfort and ease.

The garments were made accessible through mass production and, at the height of the company's success, were sold from hundreds of outlets across the globe. Combining intricate smocking and floral prints, the Laura Ashley look was romantic and nonconfrontational – thus the perfect look of purity and modesty for the young Lady Diana Spencer, who was photographed wearing Laura Ashley when she first hit the headlines in 1981.

Right: With the introduction of her maxi dress in the mid-1960s, Laura Ashley brought a touch of Victoriana to the high street. This image conveys the volte-face in taste of the period from futuristic hedonism to wistful, nostalgia-laden romance.

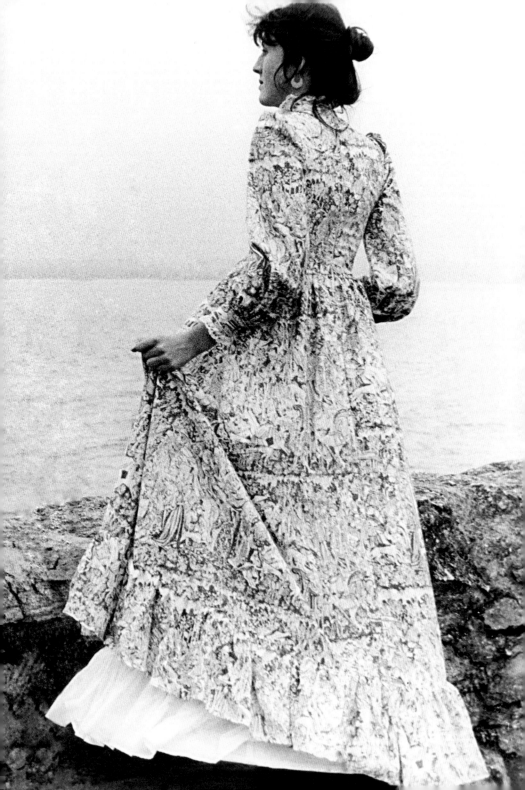

METAL DISC DRESS

In the technological and manufacturing frenzy that followed the end of World War II, new materials such as PVC and sheet aluminium generated enthusiasm for a new visual language, provoking some designers to rethink and reinvent the traditional skills of the couturier. The Spanish-born designer Paco Rabanne (1934–) even went so far as to describe himself as an engineer.

Rabanne brought together combinations of hard-edged materials not previously considered appropriate to clothing design. His experimental construction techniques produced a contemporary form of chainmail that shimmered and twinkled around the body, producing a catwalk spectacle that looked more like rocket hardware than high-end fashion.

Rabanne's decision to boldly go towards new fashion frontiers crystallized in influential garments such as the metal disc dress. Perhaps not the most practical of garments to wear, it nevertheless represented a playful vision of the future – a vision soon to be immortalized in Rabanne's designs for Jane Fonda as the heroine of the cult erotic sci-fi film *Barbarella* (1968) which quickly gained cult status.

Right: The glittering, shimmering spectacle of Paco Rabanne's metal disc dress is shown off by a shoeless 1960s dancer. Below: The articulation of the dress, recalling chainmail, meant it could hold tightly to the body when still.

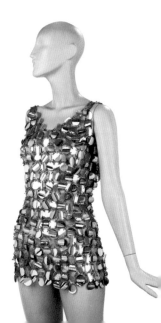

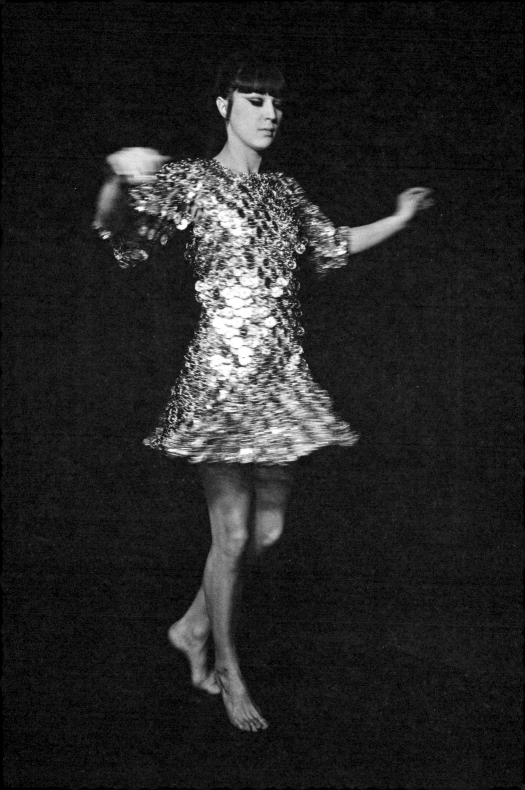

SAFARI DRESS

Out of Africa and into the wardrobe of the no-nonsense working girl, the safari dress roars utilitarian chic.

This dress, from Yves Saint Laurent's 1968 Saharienne collection, gave a new twist to the colonial look. Using a neutral palette inspired by traditional khaki shirts and breeches, Saint Laurent created a look that used subtlety rather than chromatic intensity to express assuredness and style. With its practical buttons, pockets and belt, this shirt dress was a simple statement in cool beige cotton. What a pleasure it must have been to escape the role of scrutinized gazelle and become the hunter not the hunted for a while!

The safari dress has developed into a genre, reinvented from generation to generation and season to season with subtle variations of cut, colour, button or belt to bring it up to date. Ready for action and prepared for every danger … this is what to wear when out on that fashion hunt.

Right and below: With pockets, straps and belts galore, Yves Saint Lourent's Safari dress is armour for the urban huntress as she sets out to capture her prey.

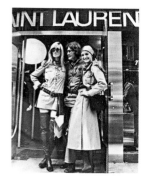

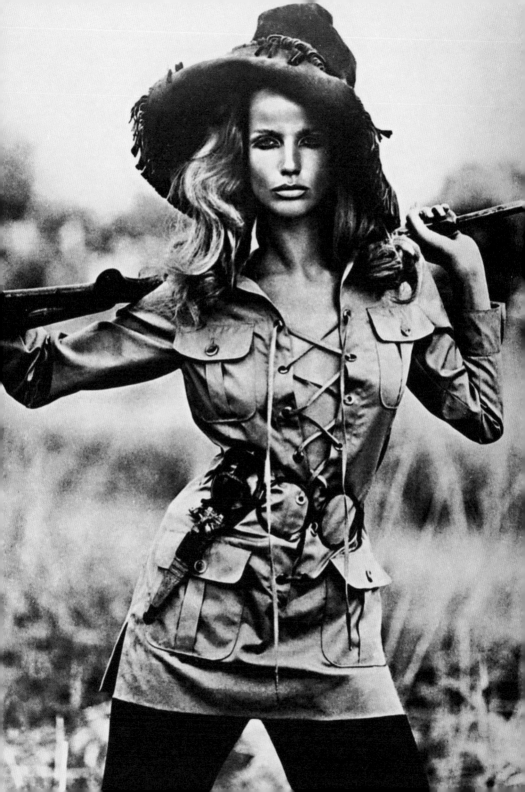

PAPER
DRESS

In 1966, as part of a clever marketing campaign promoting innovation in paper technology, the world's leading manufacturer of toilet tissue created a low-cost paper dress. One would imagine that the Scott Paper Company never aspired to make a splash in the world of haute couture, but by chance this garment tapped into evolving consumer trends that are still prevalent in the high streets of today.

The garment was made out of Scott's Dura-Weve paper fabric, originally intended for medical products such as linen and protective clothing. Its shapeless form was immaterial, as what it represented was an opportunity to consume at a rapid rate without breaking the bank. To everyone's surprise, tens of thousands of paper dresses were sold. A brief trend was born that rapidly spread from the supermarkets of the United States to the rails of London's Carnaby Street. Just like plastic cutlery, you used it and then threw it away.

Though some designers evolved paper garments that could be washed and kept, the general idea was to make clothing that was both cheap and disposable. How practical and tempting it would be to travel with barely any luggage and, at your destination, buy a new paper dress that, at the end of an evening out, could go into the bin! Sadly, our modern green sensibilities forbid us such a fantasy.

Right: Two variations of the paper dress showing how the material could be adapted to give various disposable styles.

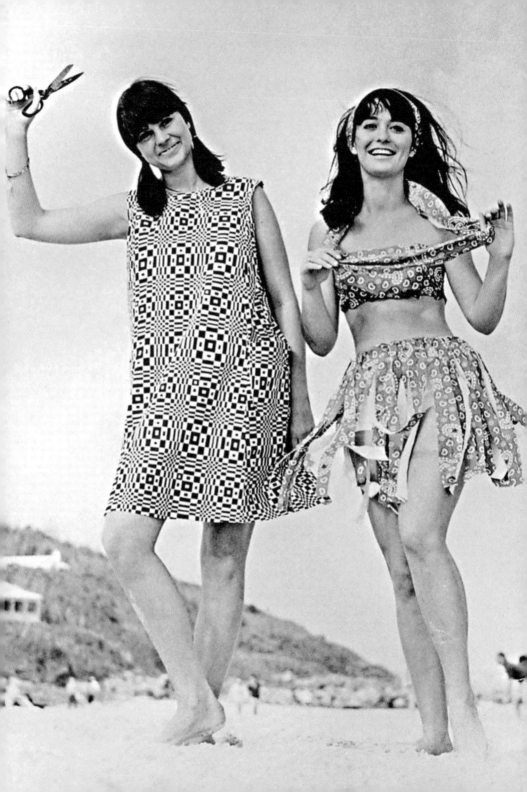

MIDI
DRESS

Jean Muir (1928–95), one of the most successful of twentieth-century British designers, has come to symbolize a certain kind of sophistication – elegant, restrained and quintessentially English. But this look from 1968 is fascinating in its prescience, introducing a longer hemline, a softer shape and more surface decoration. In these respects the dress, like the Laura Ashley maxi dress (see pages 38–9), signal led a sea change in the mood and direction of British – and, indeed, international – fashion.

The silhouette is vaguely Edwardian, demonstrating the contemporary vogue for second-hand clothes (the term 'vintage' was not yet invented). In the contemporary film *Smashing Time* (1967) – a satire on Swinging London – Rita Tushingham's ingenue character, Brenda, can afford only to buy a tatty old Victorian nightdress, an unwitting choice that actually placed her at the cutting edge of fashion.

There is a playfulness and theatricality to Muir's design, reflecting the growing sense that women were rebelling against the conformity of the 1960s 'Mod' look and now wanted to plunder the dressing-up box of history. This new romanticism must have felt startlingly new and would continue as a big influence throughout the 1970s. It was from this moment that the miniskirt went into a period of decline.

Right: The romantically nostalgic style of the gownlike midi dress perfectly caught the spirit of the attic-raiding anticonsumerism of the late 1960s. It is not too hard to imagine this as a dress worn by Jenny Agutter's character in the 1970 film *The Railway Children*.

DRESS AND COAT

At the crest of a wave that was all about free-spirited fun and fantasy, Ossie Clark (1942–96) and Celia Birtwell (1941–) were collaborators in the creation of flowing and imaginative dresses. The trend for mechanized modernity was well and truly over. This was the moment for the female form to regain freedom and movement, for individuality to be celebrated with pride.

Clark was a master cutter, fascinated by the way fabric moved. He believed that if a woman felt confident, she felt beautiful, too. His fluid designs were all about allowing a woman to be herself, unrestricted in physical movement and able to express who she was and how she felt. He began to work with the textiles designer Celia Birtwell in 1966. Their partnership was eventually cemented in marriage and recorded in the famous painting by David Hockney, *Mr and Mrs Clark and Percy* (1970).

Birtwell's floral designs captured all the period's joyous appreciation of colour and pattern. To provide fabrics that harmonized with Clark's work, she would draw up her compositions on three-dimensional models so they would look exactly right when transferred onto draped and folded forms. In spite of Clark's dislike of the diminished quality that so often came with mass production, the duo's winning combination of sunny patterns and liberated form quickly filtered onto the high street, enabling everyone to embrace the escapism.

Lately Birtwell has found a fresh generation of fans through exhibitions and sell-out limited-edition ranges for Topshop.

Right: A detail showing the intricate yet bold fabric designs of Celia Birtwell wrapping around the folds of an Ossie Clark outfit. Below: The combination of flowing cut and striking surface pattern makes a unified and dramatic statement.

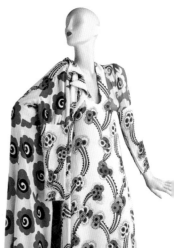

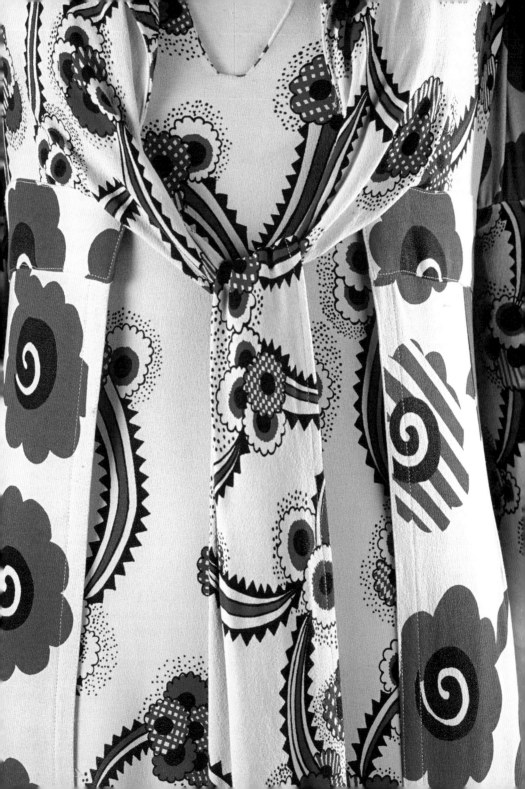

TOPLESS DRESS

The 1960s miniskirt had offered women the chance to reveal more of themselves than had ever been socially acceptable before. This was an energetic physical liberation that gave women a new confidence and a strong, positive identity. The topless dress, however, fell into a distinctly different category.

Created at the time of an emerging new wave of feminist thinking, the dress sat uncomfortably amid the questioning of male and female relationships in society, and could be judged as an example of men designing for women with objectification firmly in mind. Perhaps the best that can be said of the dress was that it demonstrated that fashion still had the power to shock – a crucial sign of life in any art form – and that, in any case, unlike the mini, this dress was never going to have wide appeal.

Its US designer, the Viennese-born Rudy Gernreich (1922–85), went on to design the Luna wear for the 1970s sci-fi classic *Space 1999*. Curiously, these gut-hugging, two-piece uniforms were about as covered up as you could get and predicted the later sportswear-as-leisurewear movement.

Right: Another example of fashion's youthful effervescence in the 1960s, or a sexist cheap shot? Controversial at the time, the topless dress has sometimes been described as a liberator of the human form but more often as an objectifier of the female body.

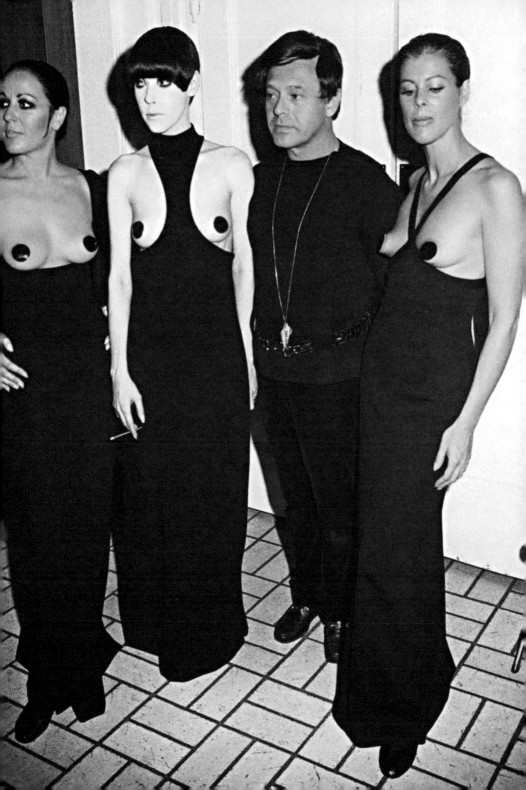

TWIGGY'S OUTFIT FOR THE LOS ANGELES PREMIERE OF *THE BOY FRIEND*

1971
Bill Gibb

By the early 1970s free(er) love and self-celebratory introversion was in the air. The hippie era had arrived with its rule-breaking eclectic ensembles, in the accelerating swing away from the depersonalized modernism of Mary Quant (1934–) and André Courrèges (1923–).

Scottish fashion designer Bill Gibb (1943–88) was at the forefront of capturing the flavour of the hippie moment, combining the romance of medievalism with a syncretic mix of shape, texture and colour plundered from a kaleidoscopic diversity of cultures. Floating, decorative and romantic, the look was about conjuring up a mood around the wearer through multiple layers of body-covering patterns, pleats and folds.

Gibb launched his first collection in 1972 and for a few short years provided the look for the great and the good on both sides of the Atlantic, including Elizabeth Taylor and Twiggy. Hampered by poor business skills, however, his time in the spotlight proved sadly brief. More recently, a revival of interest in his legacy has rediscovered the quirky individuality and decorative ingenuity in which his work abounds.

Right: Iconic fashion model Twiggy dressed in the extravagantly eclectic dress designed by Bill Gibb.

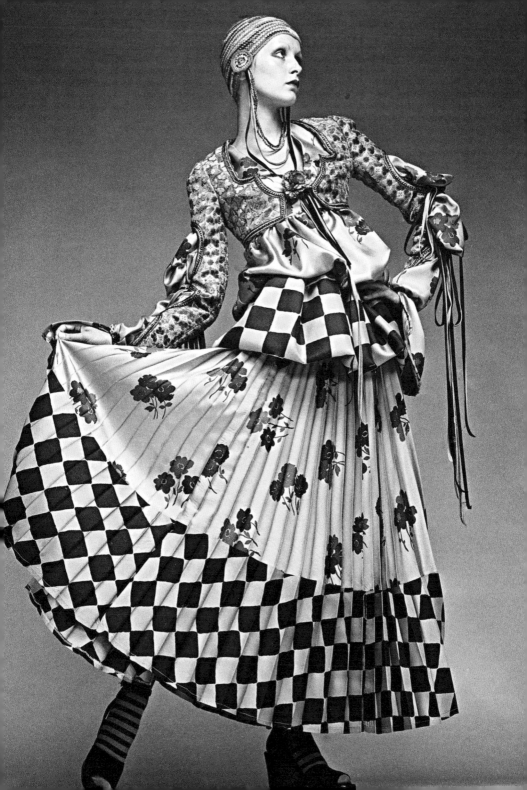

WRAP DRESS

1973
Diane von Fürstenberg

It was *the* look of the mid-1970s – a knitted jersey one-piece with a belt that, let's face it, was not that far removed from a dressing gown. But the wrap dress was – and is – not just about comfort. It is a statement of purpose and practicality, of paring down to the essence of aspiration and desire. For its designer, the Belgian-born Diane von Fürstenberg (1946–), it would be the springboard to an illustrious career.

Simplicity itself, the wrap dress is easy to put on, easy to wear and, crucially, easy to take off. The offspring of feminism and consumerism, the garment emerged at a time when women were expressing a new confidence – in the workplace, in the bedroom and on the journey in between. Comfortable, forgiving, yet slick and sexy, it was the ultimate 'go-anywhere' dress.

In 1997 Fürstenberg relaunched her high-end line and the wrap dress reemerged to become the day dress of the Noughties, too. The high street also got in on the act, and every chain produced its own version of the DVF wrap dress. Teamed with knee boots, the wrap has become the ubiquitous sartorial shorthand for modern female professionalism – the business suit for women. Professional but individual, serious but approachable, it is an über-dress for our times.

Right: A recent reissue of the classic Fürstenberg wrap dress demonstrates that this simple and versatile outfit is still relevant three and a half decades after it first appeared. Below: Designer Diane von Fürstenberg with Pop artist Andy Warhol.

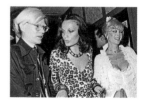

54

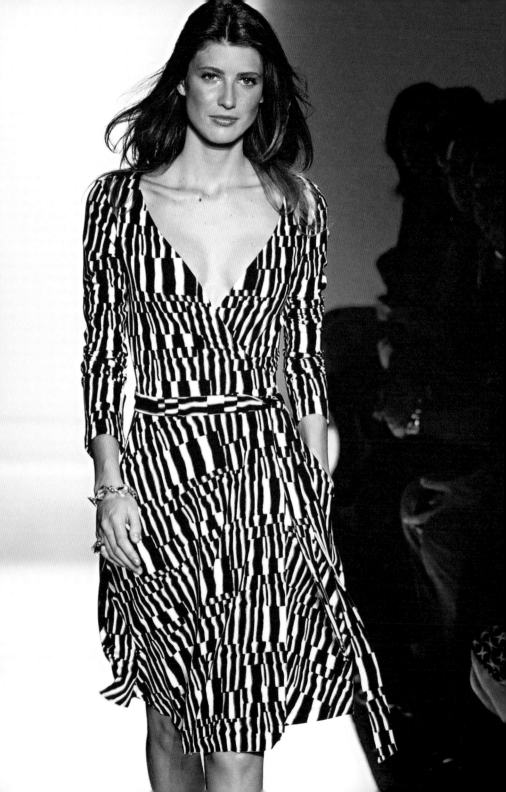

MID-LENGTH KNITTED STRIPY DRESS

The design duo behind the Milan-based fashion house Missoni, husband and wife Ottavio (1921–) and Rosita (1932–) Missoni, are famed for having turned knitted clothing into something of an art form. They are nonetheless advocates of informal dressing: their kaleidoscopically coloured garments are simply cut and comfortable to wear, and have thus retained their appeal through several generations and through numerous changes in fashion.

The rich, abstract patterning favoured by the Missonis may have its origins in the Modernist aesthetic – in the textile designs, for example, of the Bauhaus teacher Gunta Stölzl or of the Russian Constructivist Liubov Popova – and may also have taken some of its inspiration from the perceptual experiments of the Op Art movement, popularized by artists such as Bridget Riley and Victor Vasarely. Nevertheless, in the context of the early 1970s, Missoni's emphasis on traditional techniques and materials confirmed the shift in fashion away from space-age modernity and towards what the Italian style icon Anna Piagga jokingly dubbed 'haute bohème' – high-end bohemia.

Right: The frenzy of rhythmic patterning combines with delightful detail and confident colour in this classic Missoni outfit from the mid-1970s.

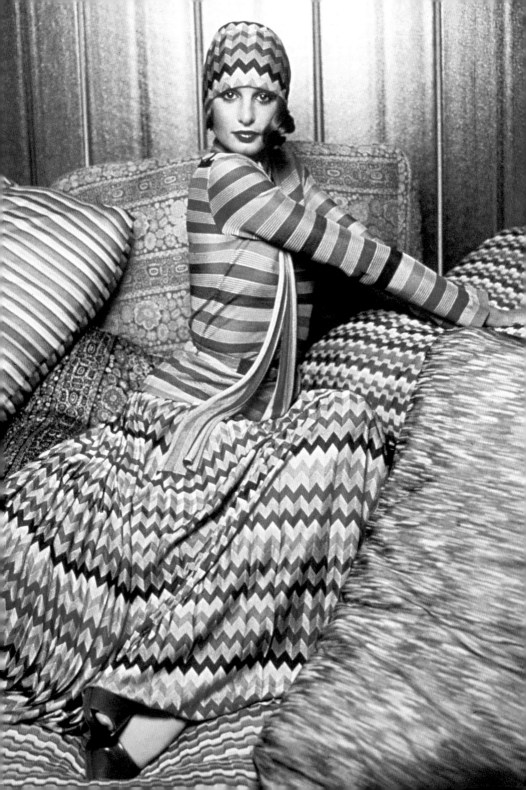

HALTERNECK DRESS

c.1977
Halston

No self-respecting mid-1970s discotheque would have been complete without a legion of Halston-clad goddesses floating across the dance floor. The classic Halston dress, with its sultry, draped silhouette and trademark halterneck, still has the power to evoke a long-lost, pre-AIDS world of sensual decadence and uninhibited fun.

The Des Moines-born designer Roy Halston Frowick (known professionally as simply Halston, 1932–90) initially found fame as a milliner, designing the pillbox hat worn by Jackie Kennedy at her husband's Presidential inauguration in 1961. By the 1970s, however, Halston had turned to creating dresses and had become the fast-living designer to the stars – Bianca Jagger and Liza Minnelli among them. 'You're only as good as the people you dress,' the designer famously quipped. In 1973 Halston sold his name to the US conglomerate Norton Simon Industries – an innovative move for a designer at this time and one that quickly established his work as a major international brand.

Halston designed his dresses on the principle of glamorous and sexy simplicity. Pared-down shapes and a restrained colour palette bucked the trend of the ethnic look that then held sway, especially in Europe. Ultra wearable and extremely flattering, these were clothes to make you feel confident and relaxed.

Right: Designer to the stars Halston; his companion wears one of his sleek and sexy halterneck dresses. Below: The dress has a relaxed form that is sensual, comfortable but also flattering.

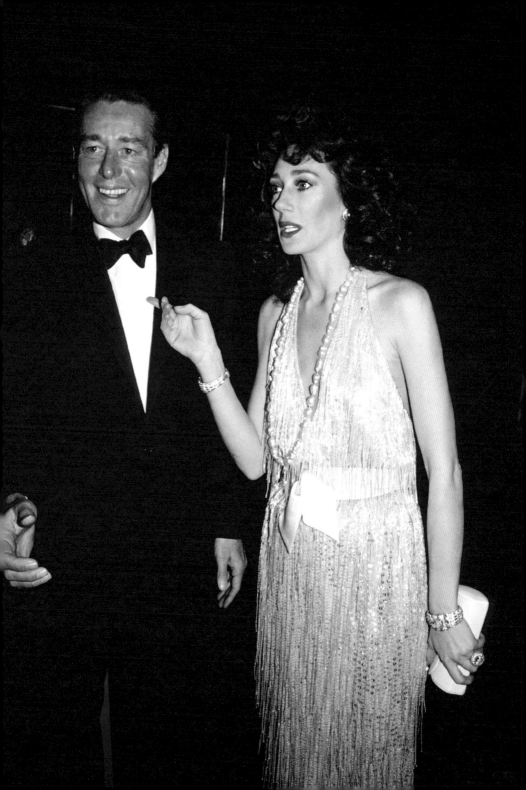

KENZO SHIRT DRESS

1977
Kenzo Takada

Kenzo Takada (1940–) was among the most influential young designers working in Paris during the 1970s – one of several Japanese practitioners to challenge the established cut and shape of clothes and to introduce what became known as the deconstructed look. While these designs may have appeared very modern, they nonetheless included elements rooted in the traditional clothing of the Near and Far East.

This dress is distinctive for its baggy, almost sack-like silhouette, a look that flourished well into the 1980s, and whose influence could still be detected in the Rave styles of the early 1990s. The dress is also notable both for its short hemline – a perhaps surprising revival of the 1960s mini, though here given a very different spin – and for its complete lack of graphic decoration. There is a strangely utilitarian flavour to its cut, one that almost anticipates minimalism.

Dresses like these would become the thinking woman's choice over the next decade. Their asymmetric and sometimes androgynous cuts managed to combine a very contemporary and questioning experimentalism with a new yearning for Zen spirituality and simplicity. This was the dress for yesterday, now, and tomorrow all at once, providing an avant-garde counterpoint to the brash excesses of mainstream 1980s designers.

Right: Utilitarian and androgynous, the Kenzo dress is also feminine and sensual with its gathered waist and short hemline.

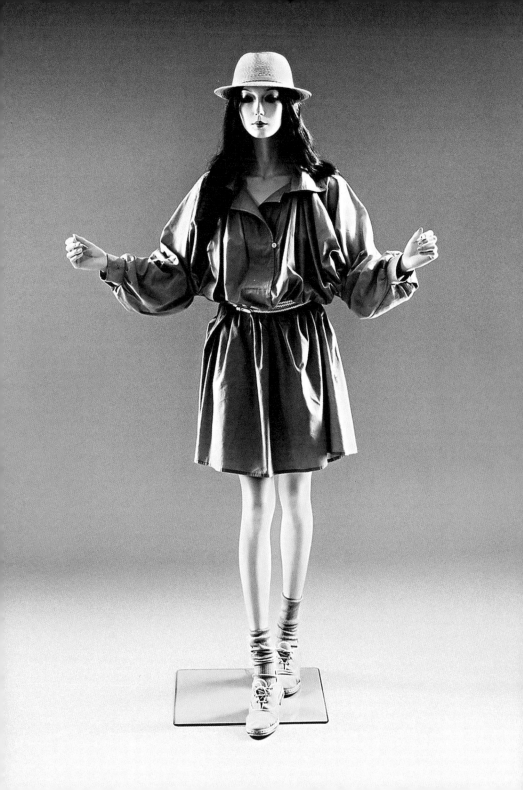

PAINTED CHIFFON DRESS

In 1969 the unconventional British designer Zandra Rhodes (1940–), frustrated by the conservatism of her country's fashion industry, decided to go it alone and opened her own shop in London's groovy Fulham Road. By the mid-1970s she had secured herself a place among the new generation of innovative and individualistic British designers. Rebellious and ambitious, she and her clothes brought a flamboyant, painterly energy to London's fashion scene.

The main focus of Rhodes's studies at the Royal College of Art had been textile design, and her work has always been noteworthy for its sensitive yet dramatic approach to fabric. Vivid colours and elaborate prints demonstrate her wealth of influences – ethnic, theatrical, historical and nature – and this, combined with innovative garment construction, allowed her to develop a unique style that glowed with grace and understated drama.

From the late 1960s through the early 1970s, Rhodes designed a succession of delicate printed chiffon silk dresses whose long flowing sleeves, plunging necklines and vibrant colours exuded a dreamy femininity.

Right: Zandra Rhodes's painted chiffon dresses perfectly illustrates her accomplished flair for textile design and sensitive use of colour.

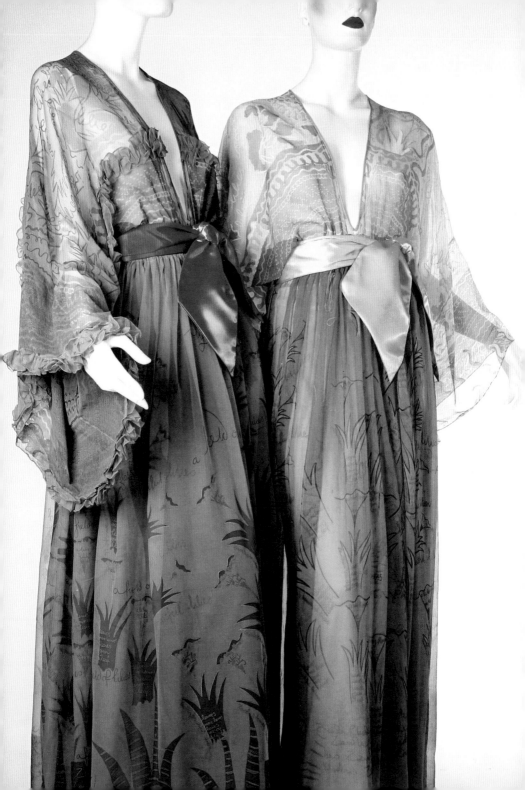

PRINCESS OF WALES'S WEDDING DRESS

1981
David and
Elizabeth Emanuel

Why is it that when you ask which dress changed the world, the answer all too often is the Princess of Wales's wedding gown?

Around the world, expectation mounted as the royal carriage approached St Paul's Cathedral. The first we saw of the future princess was a glimpse of her face amid a cloud of white, framed by the gilt surround of the carriage window. Then, as she stepped out onto the red carpet, the dress inflated into its full billowing volume and its seemingly endless train unfolded, with the aid of its creators, David (1952–) and Elizabeth (1953–) Emanuel. The creases, we were later reassured, were intentional.

The aspirations of brides-to-be would never be the same again. This was the archetypal fairytale princess dress. It brought big skirts and ruffles to the fashion fore, and re-established the wedding gown as fashion statement. With its hundreds of metres of petticoat netting, ivory silk and taffeta, its mass of ribbons and bows and antique lace, its puffed sleeves and frilly collar, and thousands of sequins and pearls, this dress was an expression of opulence and excess that foreshadowed something of the upwardly mobile tone of the decade to come.

Right: Prince Charles and Princess Diana wave to gathered crowds eager to see her long-awaited wedding dress. Below: The royal wedding dress with its astonishing train on the red carpet at St Paul's Cathedral.

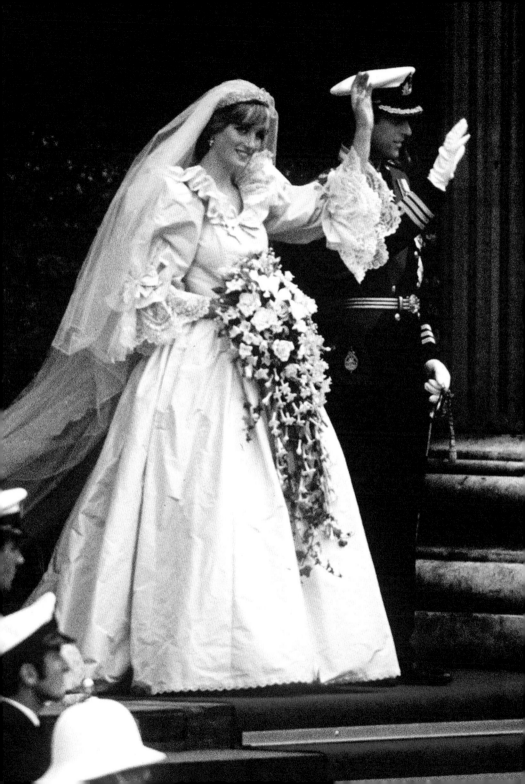

COMME DES GARÇONS DRESS

1981
Rei Kawakubo

In 1981 an unsuspecting Western audience felt the full blast of Japanese designer Rei Kawakubo's subversive originality at Comme des Garçons's first Paris show. By turns excited and alarmed by the label's monochrome and (in every sense) distressed designs, critics somewhat tastelessly described the collection as 'post-atomic' or even 'Hiroshima chic'. Like it or loathe it, the collection appeared to be an all-out onslaught on fashion's conventional, time-hallowed task of beautifying the body. It was, in short, anti-fashion.

Until this moment catwalk fashion had focused on prettifying and accentuating the female figure. Colour and pattern were there to please the eye, and black was restricted to eveningwear. Suddenly this austere, even brutal deployment of frayed and battered fabrics and a subdued palette of blacks and greys challenged the central role that beauty had always played in fashion. Why cut and drape, when you could slash, shred and twist? Why aim at symmetry and harmony, when asymmetry and dissonance were so much more expressive? Expressionism had, it seemed, finally come into fashion.

Rei Kawakubo (1942–) had established Comme des Garçons back in 1973, opening her first boutique in Tokyo two years later. In the 1980s her iconoclastic, deconstructed approach set the pace for contemporary fashion design, pointing towards the unrestrained and unrestricted discipline that it has become today.

Right: Deconstruction hits the catwalk by storm: uncompromising and bold, Rei Kawakubo's designs have lost none of their impact or brilliance.

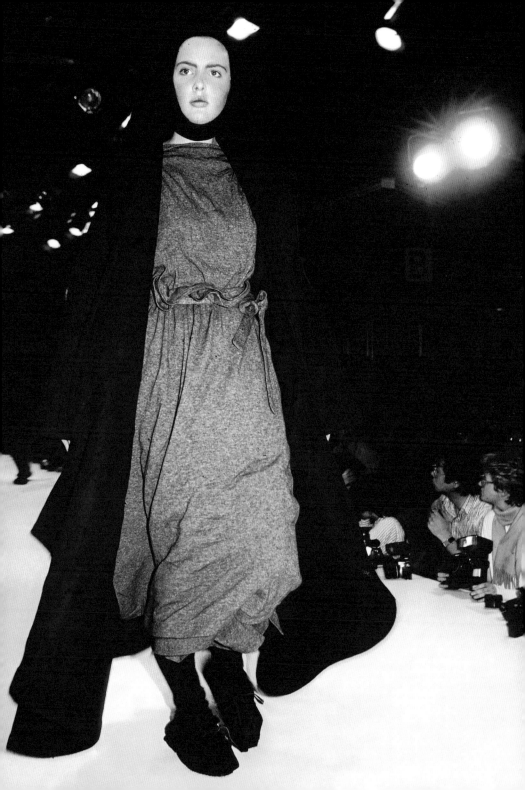

GHOST
DRESS

Some of the key moments in the history of dress are so unheralded that they barely register on the fashion Richter scale, but are seismic for all that. The iconic Ghost dress, first introduced in 1984, was one of those quiet revolutions.

The company's founder was Tanya Sarne (1949–), who, though untrained as a fashion designer, nonetheless spotted a niche. She took un-glam rayon and discovered that, when shrunk and dyed and reshrunk, it takes on the appearance and floaty sinuousness of vintage crepe. A Ghost dress has come in many shapes and sizes over the years, and has flirted with other styles (Goth and Victorian) and fabrics (satin and velvet), but essentially it has remained the same: a bias-cut, clinging dress in ethereal viscose that looks totally modern while also evoking the frocks of yesteryear – a 1930s gown, a 1940s tea dress, even an ancient Greek goddess's daywear of choice.

Loved by travel junkies for its ability to still look fabulous after being rolled up in a rucksack, these dresses are tough yet delicate. Often deeply coloured in jewel-like shades, these beauties are flattering and wearable while remaining understated. Ghost survived Sarne's departure in 2006 to become a global British brand whose lines include fragrance and eyewear. But it was the viscose frocks that started it all. Mysterious, romantic but astoundingly practical, a Ghost dress is for life.

Right: Rayon reinvented – a Ghost dress is now a wardrobe staple, hard wearing yet eternally ethereal. Below: A Ghost model having one of those Ophelia moments.

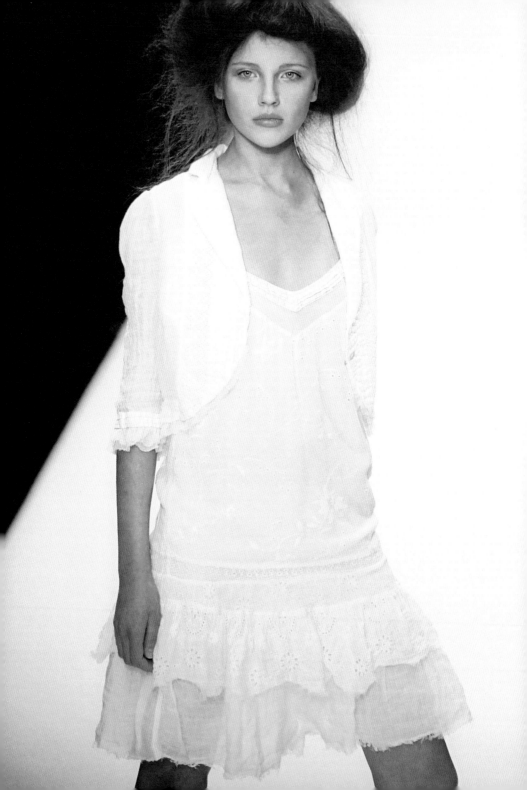

MINI-CRINI

From pioneer of punk to grande dame of British fashion, Vivienne Westwood (1941–) has always been obsessed with how hallowed tradition – whether hunting jacket, ball gown or Peruvian *pollera* – can be fruitfully reclaimed, subverted and finally reinvigorated. Through the 1980s she recklessly pillaged historical and ethnic styles as she sought to challenge the way women looked and thought about their bodies.

With the Mini-Crini, Westwood playfully appropriated both the Victorian crinoline and the tutu – both archetypically female garments – to create a dress that was at once childlike and sexually predatory. In so doing, she defied the 'inverted triangle' look – tightly held-in waist and broad padded shoulders – so pervasive in the 1980s. What women actually wanted, Westwood believed, were clothes that, rather than aping masculinity, expressed strength in an essentially feminine way.

Not so much a dress as a manipulator and enhancer of shape, the Mini-Crini is ingenious in that it can be worn both as an over-garment, with actual hoops inside rather like a lampshade, or as an undergarment that enhances the shape of the clothes worn over it. However it is worn, the effect is both balletic and alluring.

Right: The world turned upside down – Westwood's Mini-Crini combines the shape of a Victorian crinoline with a tutu to create a silhouette that turns on its head the tight-waisted, broad- shouldered inverted triangle of mainstream mid-1980s fashion.

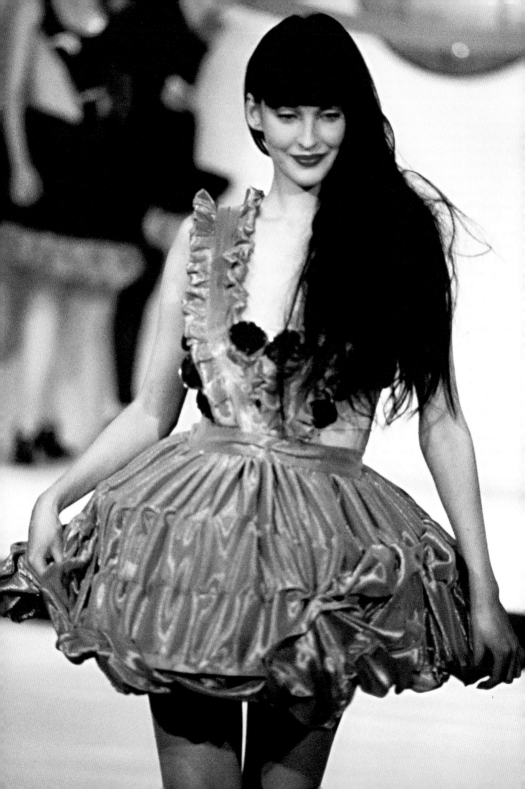

KRYSTLE CARRINGTON'S DRESS

1985
Nolan Miller

Big houses, big hair, big shoulders … the 1980s prime-time television soap *Dynasty* provided all this, together with a highly addictive, low-brow brand of escapism. How reassuring it was to know that the rich and powerful had relationship problems too, despite looking so fabulous!

The show's Emmy Award-nominated costume designs by Hollywood designer Nolan Miler (1935–) helped make *Dynasty* an international institution. Pencil skirts and padded shoulders served as the perfect couture cum armour as the two female leads, Krystle and Alexis, fought for commercial and sexual supremacy. This was battledress for the boardroom … and the bedroom, too.

To capitalize on his success, Miller designed a ready-to-wear range that took its inspiration from the show, and *Dynasty*-style glitz and kitsch soon filtered into wardrobes everywhere. Now any woman who wanted to stamp her authority in the office or at the occasional wedding reception had the perfect weapons to do so. Maligned and ridiculed as the look so often is, its hard-edged, bitchy glamour still has some purchase, as a number of Donatella Versace's (1951–) more flamboyant designs attest.

Right: Blake Carrington wisely steps back as icons of power- dressing. Alexis (Joan Collins) and Krystle (Linda Evans) prepare to wage battle.

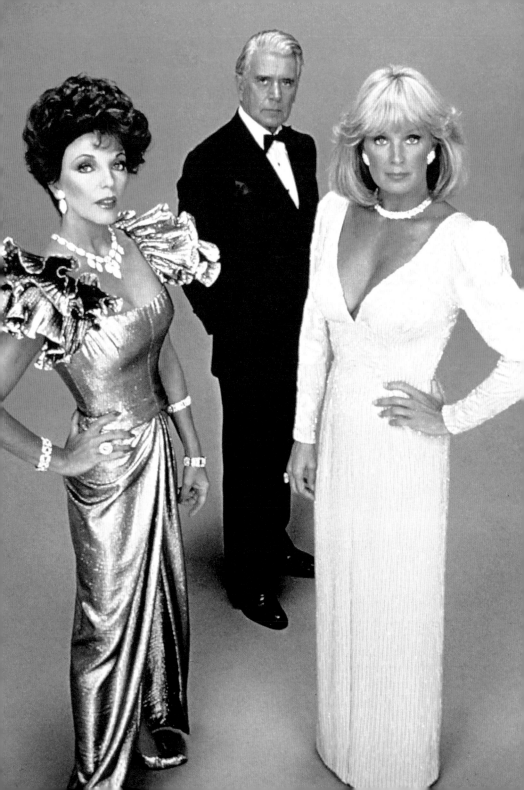

CHER'S *MOONSTRUCK* OSCARS DRESS

1988
Bob Mackie

In 1988 Cher approached the stage to receive the Best Actress Oscar for her role in the romantic comedy *Moonstruck* (1987). The movie's sweetly innocent theme tune, Harry Warren's 'That's Amore', could not have sounded more incongruous as the actress, to astonished Hollywood gasps and whoops, revealed just how revealing a gown could be. Here was a dress that was little more than a sheer and sparkling shadow cast across Cher's otherwise unclothed form.

Fringed, feminine, yet deliberately provocative, the see-through beaded dress by Hollywood designer Bob Mackie (1940–) hit the spot and got Cher noticed. But what was equally startling at the time was that this was no celluloid nymphet, but a mature woman feeling comfortable in showing off her supremely tailored body. In one photogenic swoop two taboos – near nudity with no age limit – were confronted head on.

The 'sultan of sequins' had designed outfits for Cher in the past. Another notable attention-grabbing creation was the outfit she'd worn to the Oscars two years before. Then her stretch pants, spangly loincloth, knee-high boots and oversized headdress had caused her to joke: 'As you can see, I did receive my Academy booklet on how to dress like a serious actress …'

Right: Gypsy, tramp or showgirl? Cher nearly bares all at the 1988 Oscars in the diaphanous dress designed for her by Bob Mackie.

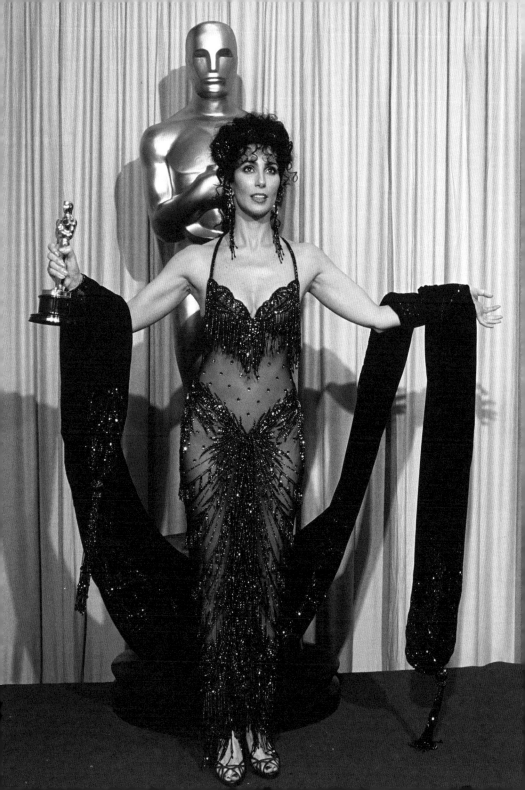

'BENDER', OR 'BANDAGE', DRESS

1989
Hervé Léger

Corsetry met Egyptology in this iconic late-1980s dress. In a moment, the 'king of cling' Hervé Léger (1957–) binned the blousy excess of 1980s style – big hair, big shoulderpads and big puff-ball dresses – to create a super-sensuous, hourglass silhouette that literally moulded women's bodies into Olympian perfection. This was consummate couture as immaculate nudity, with Lycra and Spandex-rich fabrics standing in for naked flesh.

The idea for this hybrid between underwear and overwear is said to have originated when Léger mulled over what to do with the long strips of waste fabric he found discarded in a textiles factory. To create the dress, narrow elastic fabric strips were sewn together horizontally, often with additional 'bandages' deployed to emphasize the swelling curves of hips and bust. The result was a dress that would become Hervé's signature garment, sported by many of the glamorous and famous at the time.

The bandage dress drew criticism from some, for whom the exaggerated femininity and ostentatious sexiness signalled a rekindled cultural desire to reform and deform women's bodies. For others, however, the dress is a postfeminist celebration of the female form that both confronted taboos and challenged conventions. The enduring power and appeal of Hervé's design was confirmed when the dress returned to the catwalk in 2007–8.

Right and below: Hervé Léger's body-constricting creation provoked controversy and criticism but reappeared on the catwalk in 2007–8.

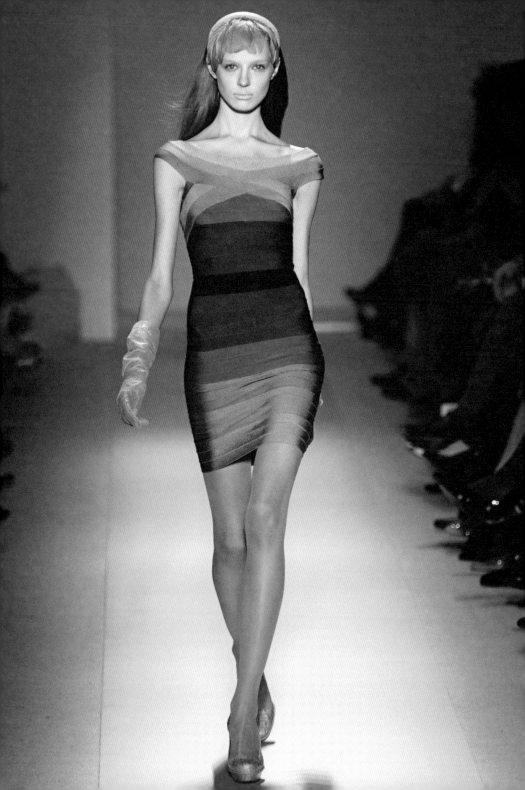

SHIFT DRESS

Fashion design that looks simple is more often than not the result of a masterly understanding of the craft. To achieve simplicity, a dress must be supremely well cut and incorporate fabrics that complement the structure; in this way the garment will hang neatly, without any unsightly bumps or creases. While today Calvin Klein (1942–) – or rather the brand that bears his name – may seem synonymous with a certain kind of bland globalization, the US designer was not so long ago heralded as a gifted purveyor of clean, classic design – a more than worthy heir to the likes of Yves Saint Laurent (1936–2008).

Something of Klein's forgotten genius can be seen in this short strapless shift dress, dating from 1990. In a fashion world seemingly brimming over with ruffles and pleats, such quiet and subtle creations came as a breath of fresh air. On the catwalk Klein's makeup-less models showed how they should be worn – with confidence and ease. The merest embellishment … and the perfection would be lost.

Klein's shift dress, in its myriad forms, launched a look that would become the ubiquitous uniform for partygoers for years to come. The 1990s was a decade in which the ostentatious opulence of the 1980s gave way to a more modest 'less is more' attitude. Dress codes were relaxing, at work as well as at play, and the shift dress provided a poised, understated look, even as millennial anxieties began to creep in …

Right: A fresh take on a 1960s classic. Power-dressing for the new age?

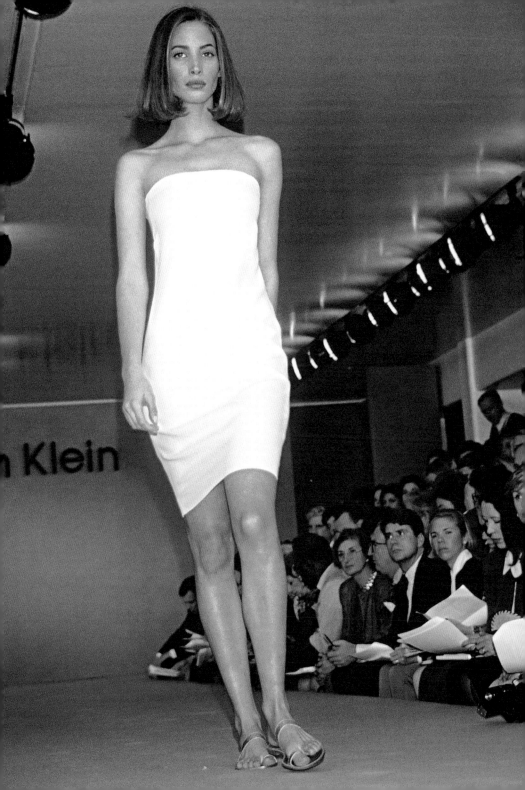

BURIED
DRESS

In 1993, at his Central St Martins graduation show, the Turkish Cypriot-born British designer Hussein Chalayan (1970–) threw down a radical challenge to the fashion industry … and, more specifically, to its commercially skewed values. The collection, entitled, somewhat obscurely, The Tangent Flows, consisted of garments that the designer had previously buried in his back garden and left to decompose. The results were far from pretty but, paradoxically perhaps, they caused a fashion sensation, and the luxury London boutique Browns bought up the entire collection.

Chalayan's show tested the boundaries between fashion and art, and asked incisive questions about the role of both design and designer. Can a dress primarily exist as the expression of an idea, even if this flies in the face of every commercial and manufacturing convention? Should a designer be limited to traditional materials and techniques, or is there scope for him or her to transcend boundaries by mixing disciplines?

Chalayan prefers not to call himself a fashion designer. His primary focus is not fashion itself, but how the body is influenced by the world around it – by not just its physical environment but by its social and cultural context as well. It is a challenging vision that over the years has inevitably produced its ups and downs in terms of Chalayan's career. However, in more recent times the designer's determination, passion and intellectual rigour have born fruit in some of the most beautiful designs of the new millennium.

Right: Hussein Chalayan came to prominence at his graduation show at Central St Martins College of Art and Design in 1993 with the Buried dress that established him as a pioneer of a new wave of deconstructionism in fashion.

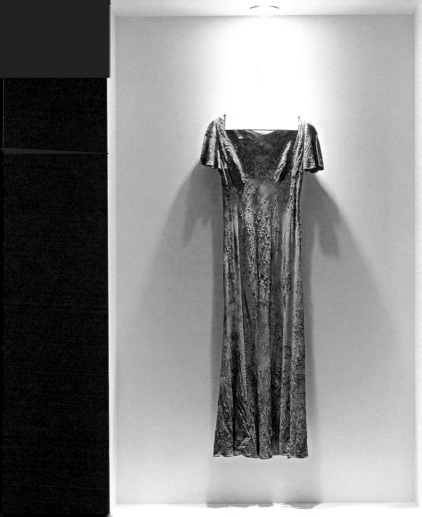

PLEATS PLEASE DRESS

1993
Issey Miyake

Avant-garde Japanese designer Issey Miyake (1938–) is renowned for his innovative approach to technique, in which he defies traditional design and manufacturing methods as he tirelessly pursues new visual vocabularies. Undoubtedly, the best known of his innovations is the revolutionary process of 'garment pleating', first introduced in 1993 and still marketed under the designer's Pleats Please line.

In the Pleats Please process, single pieces of high-grade polyester are cut and sewn to create garments as much as three times the size of the finished dress. Each oversized garment is then sandwiched between sheets of paper and hand-fed into a heat press, from which it emerges the correct size and with a structural pattern of horizontal, vertical or zigzag pleats. The result is a dress that is both architectural and organic and that moves and flows with the body. Vibrant colour – as well as texture and form – adds to the sensuousness of Miyake's designs.

Against all appearances, Pleats Please dresses are extremely practical – both to wear and to look after. (Wearability has always been one of Miyake's chief concerns.) Rolled up in a suitcase or pulled out of a washing machine, they never crease, do not need ironing, and never loose the intricate and buoyant structure that makes them float around the body so elegantly.

Right and below: The sculptural elasticity of the permanent pleats define body contours and also create volumetric shapes around the figure that evolve with movement.

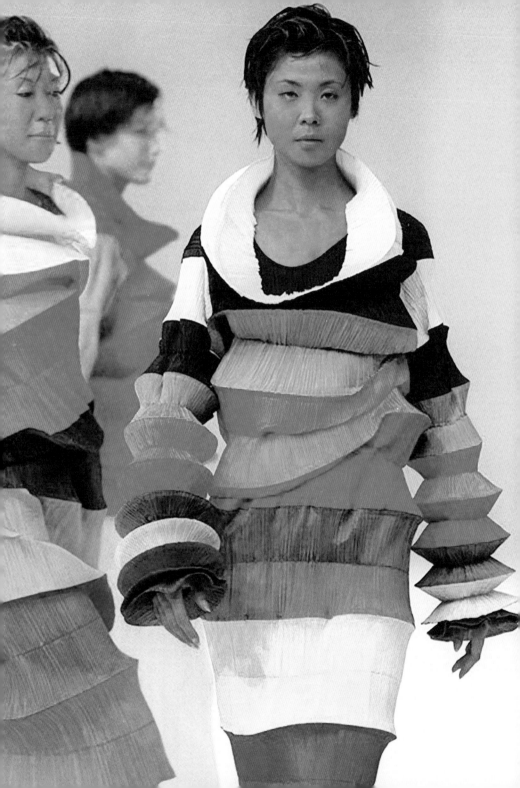

BLACK PLEATED CHIFFON DRESS

1994
Christina Stambolian

There have been few dresses that have had the media impact generated by the black pleated chiffon dress worn by Diana, Princess of Wales to a *Vanity Fair* dinner at London's Serpentine Gallery in 1994. This was no normal paparazzi moment, however – for this was the night when, in an unprecedented television interview, the heir to the British throne, Prince Charles, publicly admitted to adultery. That in itself should have been the show-stopper. Instead, the Prince was eclipsed by the Princess's strength and independence as she defiantly strode through the gallery's doors in an electrifying off-the-shoulder dress and high-heeled Manolo Blahnik shoes.

The 'Revenge Dress', as it was quickly dubbed, was by the then little-known Greek designer Christina Stambolian. To don this frock – which was a little shorter and a little sexier than the public were used to seeing the Princess wearing – was a gesture of both vulnerability and challenge. In the ongoing battle for media attention, Diana proved victorious, as, on the following day, photographs of the plucky Princess swept Charles and his heartfelt confession straight off the tabloids' front pages.

The idea of power-dressing is hardly new, but this celebrated example demonstrates the impact of the right outfit worn at the right time by the right person.

Right: A graceful sketch of the 'Revenge Dress' showing its figure-hugging silhouette and gathered skirt. Below: The Princess in Hyde Park outside the Serpentine Gallery wearing the dress to sensational effect.

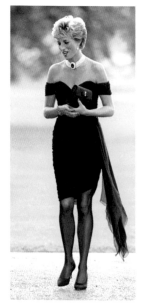

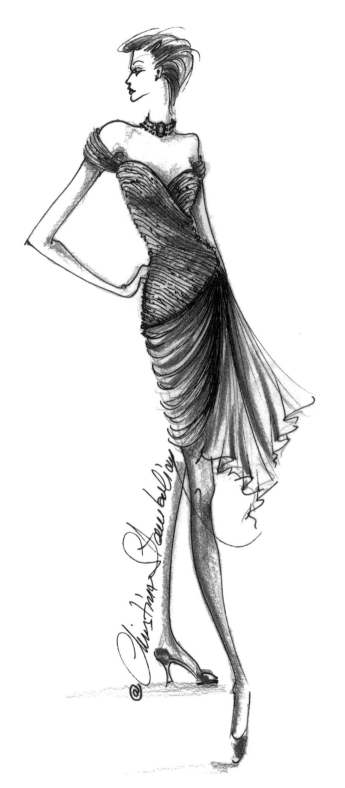

SAFETY-PIN DRESS

1994
Gianni Versace

This was the dress that changed Elizabeth Hurley's career. As a piece of couture, it might seem inconsequential, ephemeral, but what dress better demonstrates the power of fashion? In a moment as brief and vivid as a camera flash, this one dress was illuminated and broadcast around the world. A plunging neckline and oversized golden safety pins were all it took.

Here Gianni Versace (1946–97) was plundering punk, early Vivienne Westwood (1941–) and good old-fashioned film-star glamour to create a dress that was entirely of its time – a monument to 1990s celebrity culture and faintly ironic bling. It was the dress that would launch a thousand more preening red-carpet moments – here they come, the wannabes and has-beens, hands on hips and lips pouting, in a sheen of self-promotion and anxiety – but *this* dress was the first of its kind, celebrity chic reinventing itself as postmodern porn-star glamour.

Eyebrows untamed, hair untethered, bust almost (but not quite) falling out of the barely there dress … we can almost sense that this woman is thinking she doesn't care and is really going to go for it. Which is exactly what the world then did.

Right: Look at me! Gianni Versace reinvigorates red-carpet glamour and puts the girl from Basingstoke on the celebrity map. And oh … isn't that Hugh Grant behind?

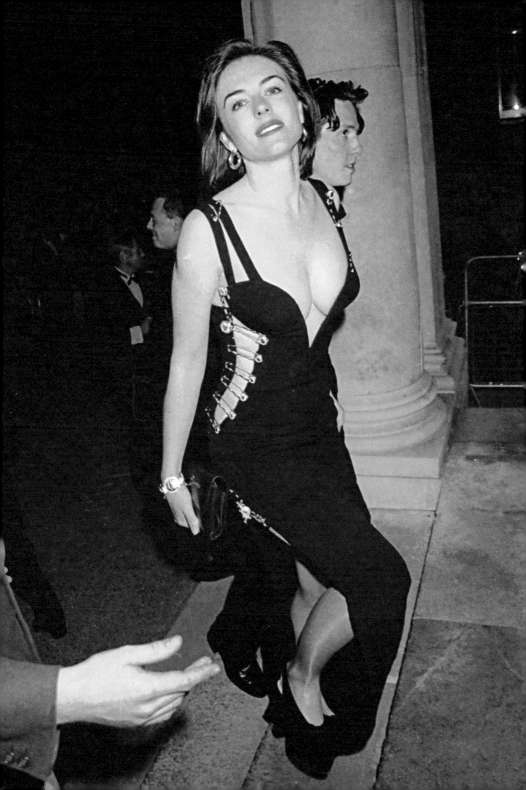

MERMAID DRESS

1997
Julien Macdonald

Back in the late 1990s, Cool Britannia really was cool, and the Welsh designer Julien Macdonald (1971–) was one of the creative individuals whose work proclaimed the UK a cultural world leader. The rise of New Labour, a vigorous economy and the pop-culture boom generated a mood of excitement and optimism that was perfectly captured in the sequinned glamour of Macdonald's dresses. It was a good time to dress up with pride.

Macdonald launched his solo label in 1997 with the Mermaid collection, which was styled by the influential magazine editor and style icon Isabella Blow. Its shimmering fabrics, well-executed tailoring and media savviness would become the hallmarks of MacDonald's career.

Sparkly, bright, chic … the Mermaid dress is somehow fun rather than demure. Everything you really, really want if you wanna be glamorous.

Right: The Mermaid dress by Julien Macdonald evoked the soaring optimism of late-1990s Cool Britannia.

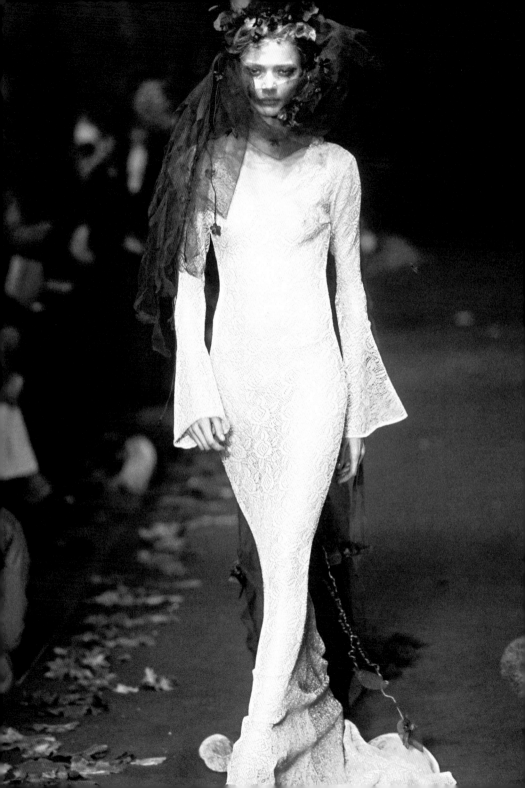

ELECTRIC ANGELS
COLLECTION DRESS

1997
Matthew Williamson

The Manchester-born designer Matthew Williamson (1971–) is one of the outstanding success stories of the contemporary British fashion industry. Graduating from Central St Martins College of Art and Design in 1994, he spent two years designing accessories for British high-street fashion company Monsoon before launching his own label in 1997 with business partner Joseph Velosa. Today, just over a decade later, he has a store at the heart of London's Mayfair and his collections are worn by celebrity clients including Madonna, Sienna Miller and Gwyneth Paltrow. In 2005 Williamson was appointed creative director at Pucci.

Williamson has always been alert to the glamour and power of the A-list celebrity. Even at his London Fashion Week debut show – Electric Angels – he managed to charm names such as Helena Christensen, Jade Jagger, Diane Kruger and Kate Moss into modelling for him. The tiny show of just 11 designs showcased the designer's love of vibrant colour and of exquisite beading and embroidery, and propelled him instantly into the media spotlight.

This simple, feminine, yet intensely coloured outfit modelled by Moss is one of the key images from the collection. Suddenly to be chic also meant looking relaxed and informal. The petite cardigan was back, but now reinvented as a glamour item. The playful combinations of intense hues were a refreshing change that caught the imagination of women who wanted to embrace this new glammed-up, dressed-down style.

Right: Kate Moss on the catwalk dressed with fabulous and intensely coloured informality established Matthew Williamson as a leader of a relaxed feminine style and reinvented the cardigan as a must-have garment.

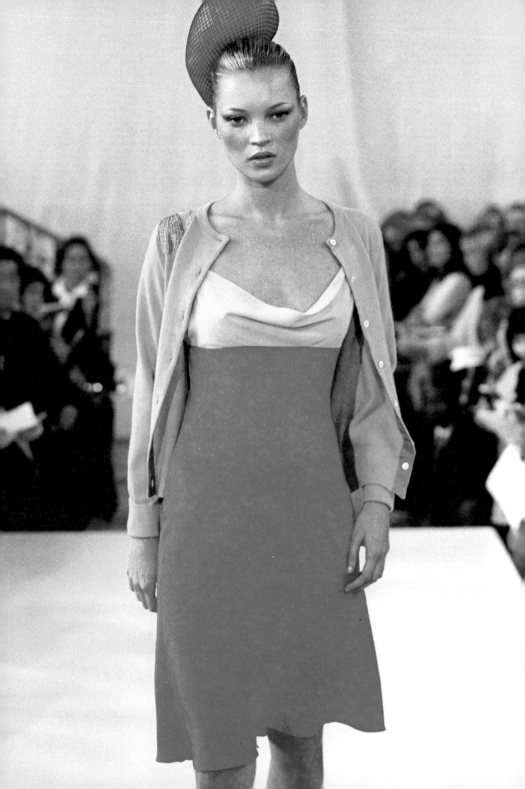

GREEN SILK BAMBOO-PRINT DRESS

2000
Donatella Versace
for Versace

Long and flowing and barely fastened with a jewelled clasp at the front, this dress is so relaxed, so revealing, it's almost an unravelled version of the iconic Diane von Fürstenberg wrap (see pages 54–55). This sensual dress – by the Italian fashion designer and Vice-President of the Versace Group, Donatella Versace (1951–) – was originally modelled on the catwalk by the US actress Amber Valletta, and it went on to become one of the most photographed frocks of 2000, worn by Geri Halliwell and Jennifer Lopez, among others.

 With its natural colours, nature-inspired imagery and untampered-with body shape, this was a piece of design that marked the apogee of a 1990s trend – one that tapped into a deep-seated need to take stock and go back to basics, as the uncertainty and anxiety attendant on the coming new millennium gathered pace. It would not be too fanciful to draw a parallel here with the *fin-de-siècle* designs of the Arts and Crafts movement, whose rich colours, intricate floral patterning and romantically tinged nostalgia also offered reassurance to a society faced with unparalleled technological and societal change.

Right: With its floral print, flowing form and simple shape, the Bamboo dress was sexy and modern, while also evoking Liberty prints from the turn of the twentieth century – a reassuring note at a time of millennial uncertainty.

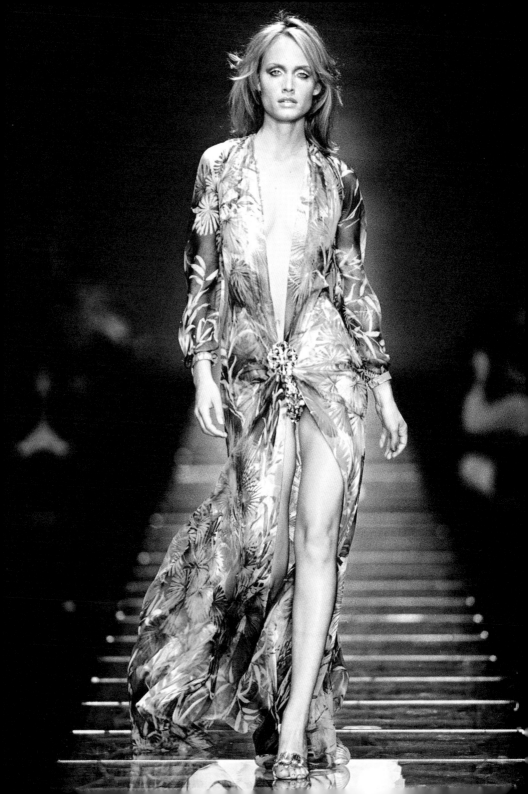

SAMURAI DRESS

2001
Alexander McQueen

The London-born designer Alexander McQueen (1969–) began his fashion career in the citadel of traditional English men's tailoring, Savile Row, where he received a thorough training in cutting, construction and hand finishing. Moving from tailoring towards haute couture, McQueen initially spent time working for Koji Tatsuno and Romeo Gigli, before returning to London in 1994 to study for an MA at Central St Martins College of Art and Design. His inventive graduation collection caught the eye of the world's fashion press and was acquired in its entirety by Isabella Blow. Despite his 'bad boy' reputation, from 1996 to 2001 McQueen worked as chief designer for the classic Parisian fashion house Givenchy.

This intense, paradox-ridden journey has frequently born fruit in fluent, postmodern masterpieces such as this gorgeous, erotically charged Samurai dress from 2001. Combining exquisite tailoring with an unabashed sensuality, the dress suggests a synthesis of the historic and iconoclastic impulses of the kind pioneered by Vivienne Westwood (see pages 68–69). Both ironic and celebratory, such designs establish him as Britain's new high priest of fashion.

Right: In this extraordinary creation Alexander McQueen demonstrated his ability to synthesize traditionalist and iconoclastic impulses.

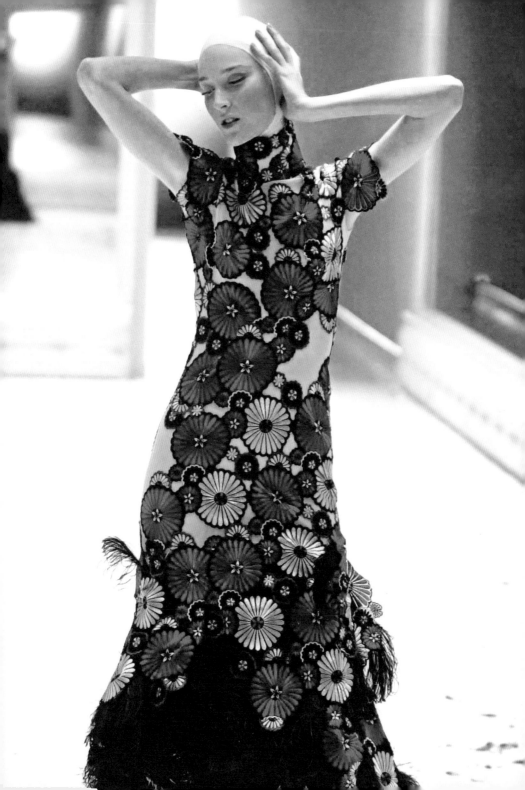

JULIA ROBERTS'S OSCARS DRESS

2001
Valentino

At the 73rd Academy Awards in 2001, Best Actress winner Julia Roberts wore a dress by Valentino (1932–), a classic Italian designer who had first made his name in the early 1960s. It was a majestic, sweeping black-and-white number and effortlessly conjured up all the glamour and pizzazz of golden-age Hollywood. A normal red-carpet moment, then … except for the fact that the dress wasn't new but vintage, dating back to 1982!

Roberts's choice of a vintage gown caused a sensation. The typical Oscars gown came fresh from the designer's fitting room – it was unique, pristine, a never-seen-before treasure that in some sense validated the wearer as someone exceptional. By breaking with Hollywood convention, the star of *Erin Brockovich* (2000) seemed to be claiming that it was the wearer's individuality that mattered most, the way she and her choice of garment worked together, whatever its origin, however old or new.

Julia Roberts's gambit helped legitimize the rise of vintage wear as not merely acceptable but desirable, discerning and chic. To chose and wear vintage was a sign of originality, an act of resistance in the face of fashion's relentless hunger for novelty.

Right: Julia Roberts's choice of dress at the 2001 Oscars marked the triumphant ascendancy of vintage dressing. Even stars were pillaging the dressing-up box.

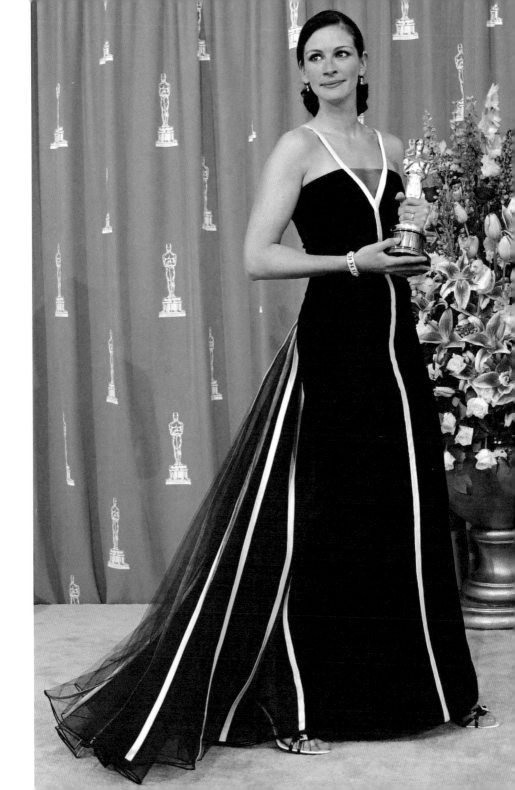

FLORAL-PRINT TEA DRESS

2004
Paul Smith

Since the early 1970s Paul Smith (1946–) has revolutionized traditional men's styling, creating tailored suits with a wisp of pattern that have helped redefine and reestablish British style across the globe. However, the playful juxtaposition of high quality fabrics, exquisite cutting and daring splashes of colour also made these garments popular amongst female consumers, so, in 1993 Smith decided to launch his own womenswear collection. Once again, tradition was revisited, reexamined and reinterpreted.

The tea dress conjures up the quintessence of traditional Englishness. Both feminine and formal, it is nonetheless relaxed enough to be worn at all manner of social occasions from a summer wedding or garden party to a drink in the local pub. Because of its attractive versatility, the flowery, floaty tea dress has been immune to generations of catwalk trends. What Smith has done is to identify this fashion veteran as a timeless British classic. Made with a signature fabric and updated at the hem and waist, the tea dress has been rejuvenated to fly the flag to a new generation.

Right and below: Paul Smith specializes in a kind of nostalgic, gently eccentric reinterpretation of 'Englishness', evoking the bygone worlds of Vita Sackville-West and John Betjeman, of garden parties and croquet lawns.

KINGFISHER-BLUE SILK FAILLE BALLOON DRESS

2005
Alber Elbaz for Lanvin

Lanvin is a revered Parisian couture house, launched by French designer Jeanne Lanvin (1867–1946), who in the 1920s and 30s became renowned for her intricately beaded and ribbon-embellished dresses. After a long period of decline, in recent years the business has been given a creative and commercial boost by the Israeli designer Alber Elbaz (1961–), whose gentle, wistful designs have revitalized the Lanvin tradition with modern detail and contemporary styling. This silk faille balloon dress is an excellent example.

Made of softened blue silk, Elbaz's design captures all the freshness and vitality of Lanvin's original work and even references the drop waist so often adopted by his forebear in the years following World War I. The dress is far from being historical pastiche, however – its striking silhouette and volume without padding (the result of ingenious tailoring) manage to give it an edgy, contemporary feel. Moreover, it is designed to be easy to wear. Put it on and forget about it – this is a dress made with people in mind rather than the catwalk.

As time passes, and fashion trends overtake fashion houses, it is interesting to see how a label such as Lanvin can remain relevant and commercially viable by embracing the creative vision of new generations of designers. This particular partnership is by no means a unique phenomenon, but here, especially, it is a marriage between past and present talent that works brilliantly.

Right: Lanvin lives again. This beautiful dress is timeless – designed for the moment yet evoking dresses of the past.

GALAXY DRESS

In his debut collection, launched at London Fashion Week in February 1998, French designer Roland Mouret (1962–) produced a series of patternless garments that were simply draped around the models and held in place with studs and pins. It was a confident gesture towards the individuality of the wearer that was to be reiterated in much of the designer's later work.

With its determination to celebrate and accentuate curves, the Galaxy dress was undoubtedly *the* dress of 2005 – a tour de force that caught the imagination of the body-confident crowd of the Noughties and won its designer a worldwide reputation. Donned by many a Hollywood celebrity, the dress drew a clean, hourglass outline that defined the shape of the body rather than obscuring it, creating that perfect red-carpet photograph.

After the Galaxy, Mouret suffered a brief eclipse as he and his company parted ways, but he re-entered the fashion firmament two years later with a line for the luxury Manhattan department store Bergdorf Goodman. The skintight Moon dress of 2007 was, like the Galaxy, another sartorial essay in body empowerment and another sally in the 'chintz chucking' mood that was streamlining the fashion world at that time.

Right: An already iconic twenty-first-century dress that still references the form-fitting glamour of the 1940s and 1950s. Below: Sexy yet wearable, is this power-dressing for the new century?

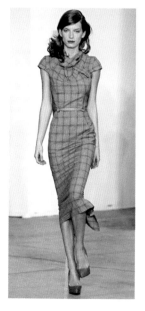

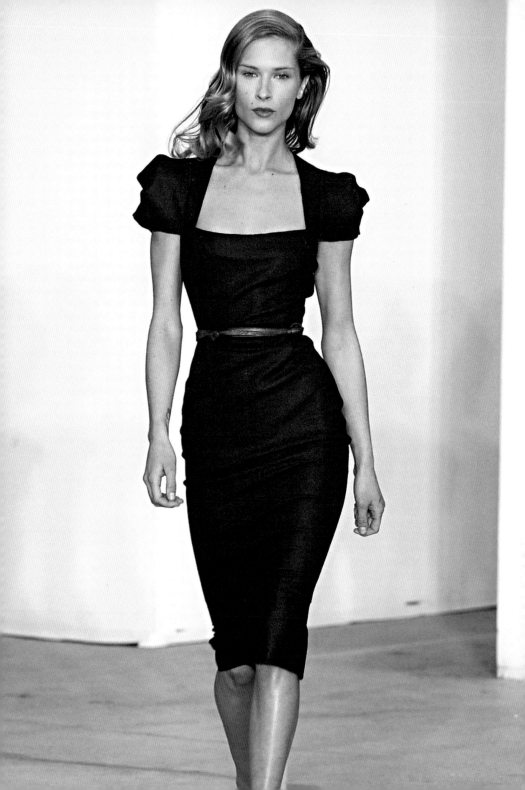

ONE-SHOULDER DRESS

On 30 April 2007 excited crowds of women gathered outside a curtained shop window on a busy corner of Oxford Street – London's prime commercial thoroughfare. The window belonged to the flagship store of the international clothing chain Topshop, and the anticipated event was the launch of a new range of exclusive clothes 'designed' by supermodel Kate Moss (1971–). Finally, the curtains were drawn back and for a brief moment there was a glimpse of the supermodel herself, sporting a red dress from the collection. Moments later, the store opened and the crowds poured in, eager for a chance to buy a little bit of the style and flair they associated with their fashion icon.

The One-shoulder dress was one of the standout items from the 50-piece collection and was a great example of how a current red-carpet style could be made accessible and affordable to a high-street audience. Nonetheless, the Topshop–Kate Moss collaboration – and similar ones between Madonna and H&M, or between Lily Allen and New Look – have attracted criticism, not least from the fashion industry itself. Hussein Chalayan (1970–) was only one of several high-profile names who have argued that celebrity branding of this kind devalues the work of designers and the integrity of the creative process.

On one level, perhaps, it doesn't really matter how much input Moss actually has in the creation of the Topshop designs. Her fans and followers know that she has had her say, and her endorsement is what counts. The high street, after all, has constantly to reinvent itself to retain consumer interest. Partnering of fashion celeb and retailer is now a tried-and-tested way of sustaining volume buying at a time when fashion is treated like a disposable commodity more than ever before.

Right: Asymmetric dresses are headline news in the Noughties. But this particular example is sanctioned by our current high priestess of fashion, Kate Moss.

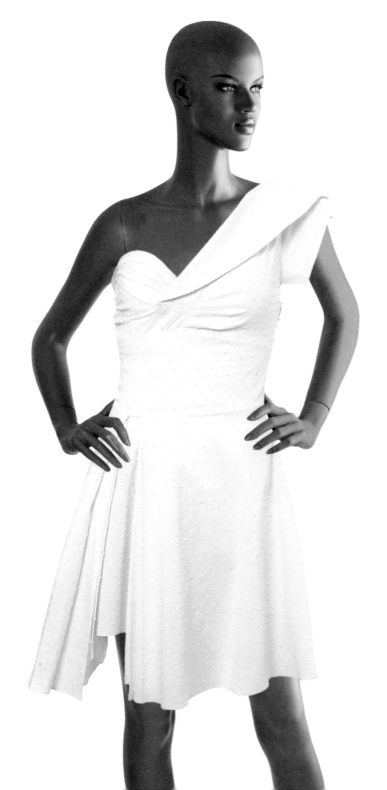

LED
DRESS

Let there be light …

Fearlessly fusing techniques and technologies, Hussein Chalayan (1970–) has never been one for being constrained by fashion's traditions or conventions. His bold choice of materials and meticulous precision hint at of his original intention of becoming an architect, and even while at Central St Martins College of Art and Design his tutors wondered whether he was not better suited to sculpture. Consistently innovative and experimental as his approach may be, Chalayan's tireless researches have nonetheless produced pieces of astonishing beauty and prophetic power.

This 'simple' white dress, shown as part of the designer's 2007 Airborne collection, was created from Swarovski crystals and some 15,600 flickering LEDs that together emit a haunting, otherworldly light. The garment represented spring in a collection concerned with the changing seasons, the cycle of life and death, and human vulnerability. The LED dress demonstrates Chalayan's preoccupation with new technologies and his skill at incorporating them into wearable yet thought-provoking designs. Rather than being a futuristic fantasy, however, this is a material expression of his current ideas, crossing boundaries between the worlds of performance art, product design and installation art.

A new century of fashion exploration is under way …

Right: Hussein Chalayan works at the cutting edge of couture, and never more so than in this science-fiction creation that has an undeniable glamour and poetry. The story of the dress is far from over.
Below: The future is bright, the future is fashion …

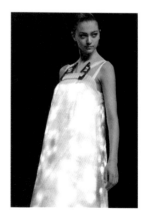

106

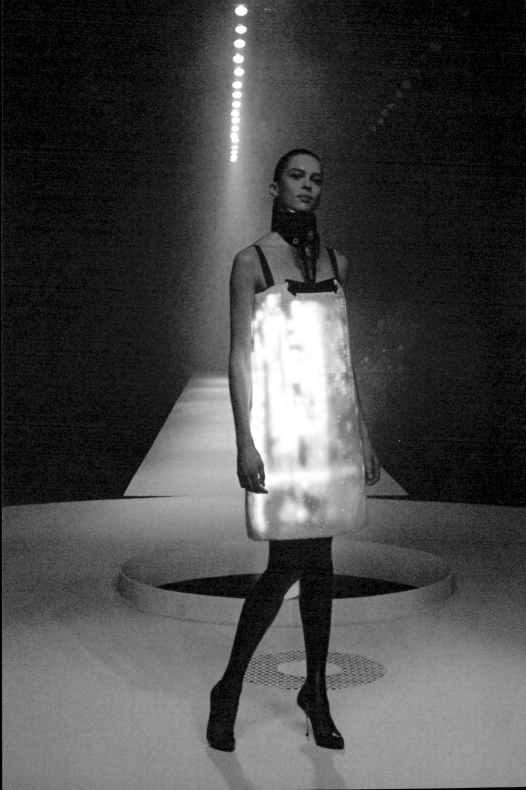

INDEX

PICTURE CREDITS

CREDITS

First published in 2009
by Conran Octopus Ltd
a part of Octopus Publishing
Group, Endeavour House,
189 Shaftesbury Avenue,
London WC2H 8JY
www.octopusbooks.co.uk

A Hachette UK Company
www.hachette.co.uk

Distributed in the United
States and Canada by
Octopus Books USA, c/o
Hachette Book Group USA,
237 Park Avenue, New York,
NY 10017 USA

Reprinted in 2010

British Library Cataloguing-
in-Publication Data.
A catalogue record for
this book is available
from the British Library.

Text written by:
Michael Czerwinski

Publisher:
Lorraine Dickey
Consultant Editor:
Deyan Sudjic
Managing Editor:
Sybella Marlow
Editor:
Robert Anderson

Art Director:
Jonathan Christie
Design:
Untitled
Picture Researcher:
Anne-Marie Hoines

Production Manager:
Katherine Hockley
Senior Production Controller:
Caroline Alberti

ISBN: 978 1 84091 538 9
Printed in China